PORTRAIT OF
OREGON

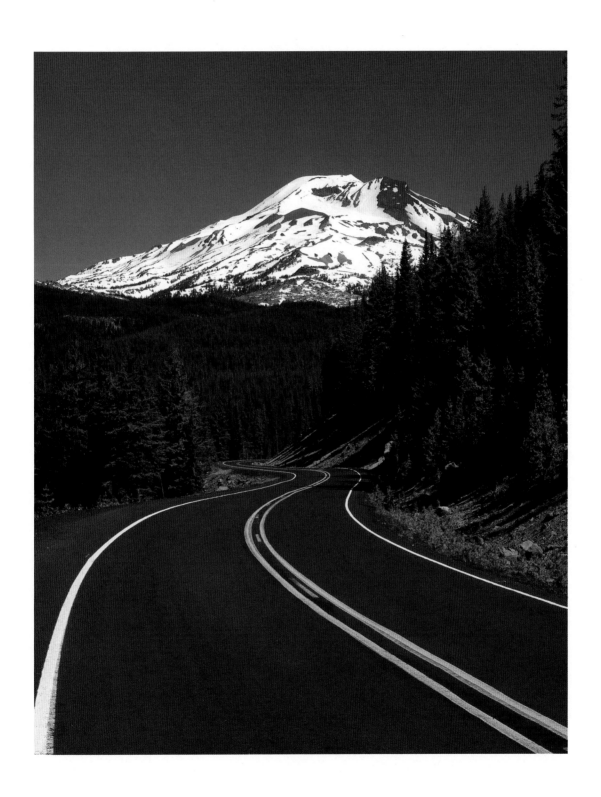

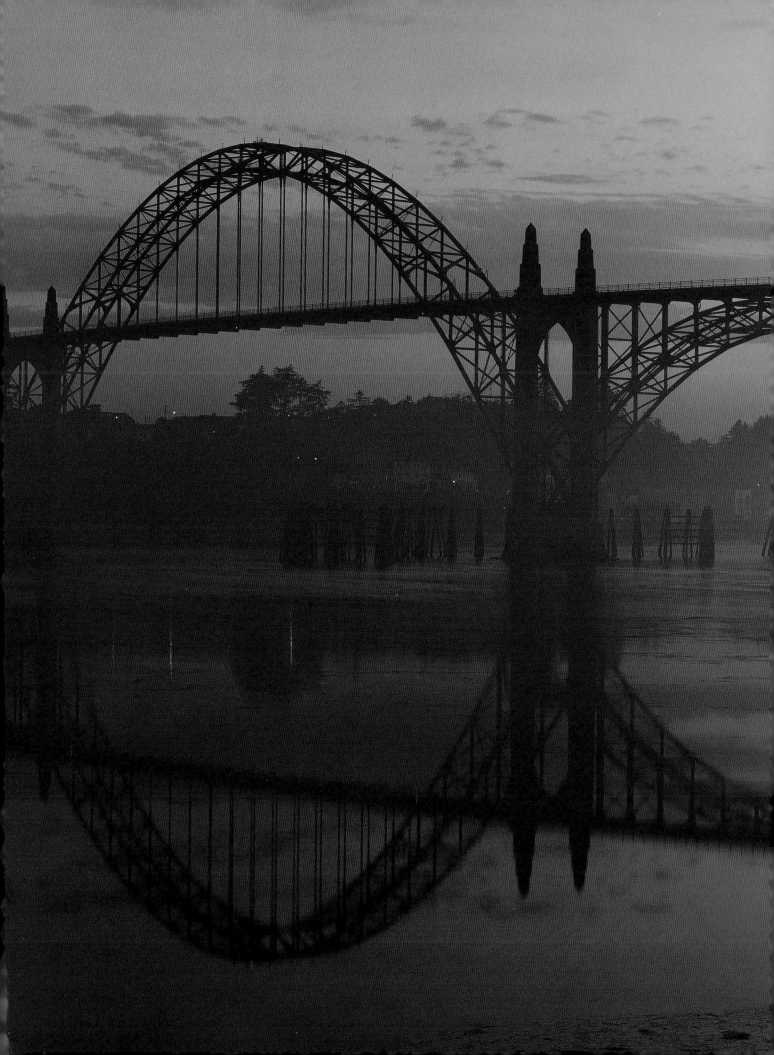

PORTRAIT OF
OREGON

Photography by Rick Schafer

Essays by Sandra L. Keith

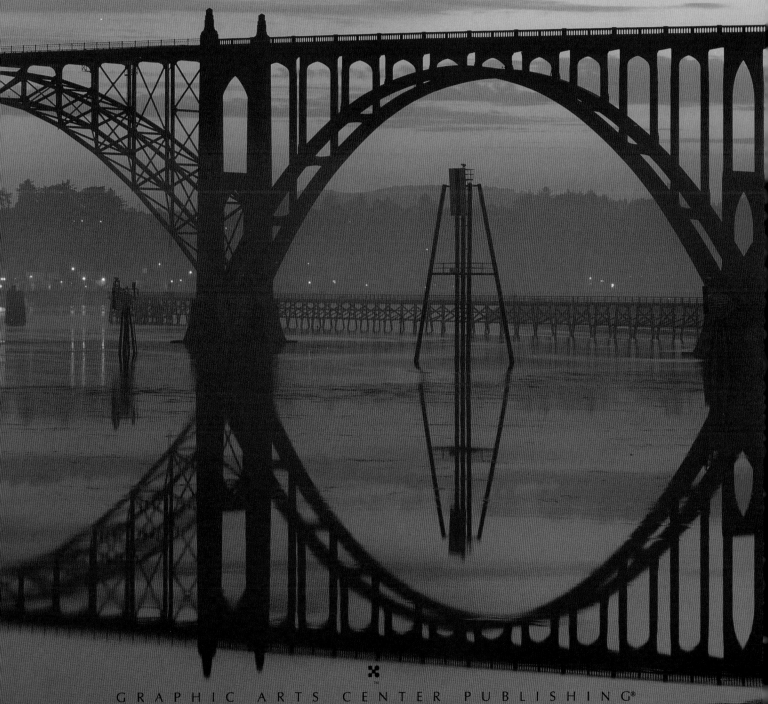

GRAPHIC ARTS CENTER PUBLISHING®

OREGON

National Wildlife Refuges
Controlled Access Highways
Other Major Highways

0 10 20 30 40 50 75 Miles

0 50 100 Kilometers

International Standard Book Number 1-55868-162-0
Library of Congress catalog number 93-73316

© MCMXCIV by Graphic Arts Center Publishing Company
P.O. Box 10306 • Portland, Oregon 97296-0306 • 503/226-2402

President • Charles M. Hopkins
Editor-in-Chief • Douglas A. Pfeiffer
Managing Editor • Jean Andrews
Production Manager • Richard L. Owsiany
Cartographer • Tom Patterson
Book Manufacturing • Lincoln & Allen Co.
Printed in the United States of America
Second Printing

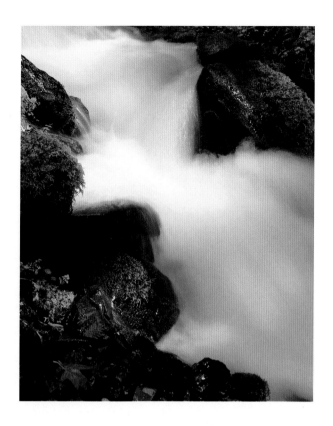

To the memory of my stepfather and mentor,
Ray Atkeson, and to my friend Kelly Fundingsland.

RICK SCHAFER

Contents

Half title page: South Sister, at 10,385 feet, is highest of the Three Sisters. It is visible along the Cascade Lakes Highway. *Title page:* The deck of the Yaquina Bay Bridge, built in 1938, rises 138 feet, so ocean-going vessels can pass beneath it. *Above:* Wahkeena Falls is visible from the Historic Highway in the Columbia River Gorge. The name is thought to have been derived from the Indian word meaning "most beautiful."

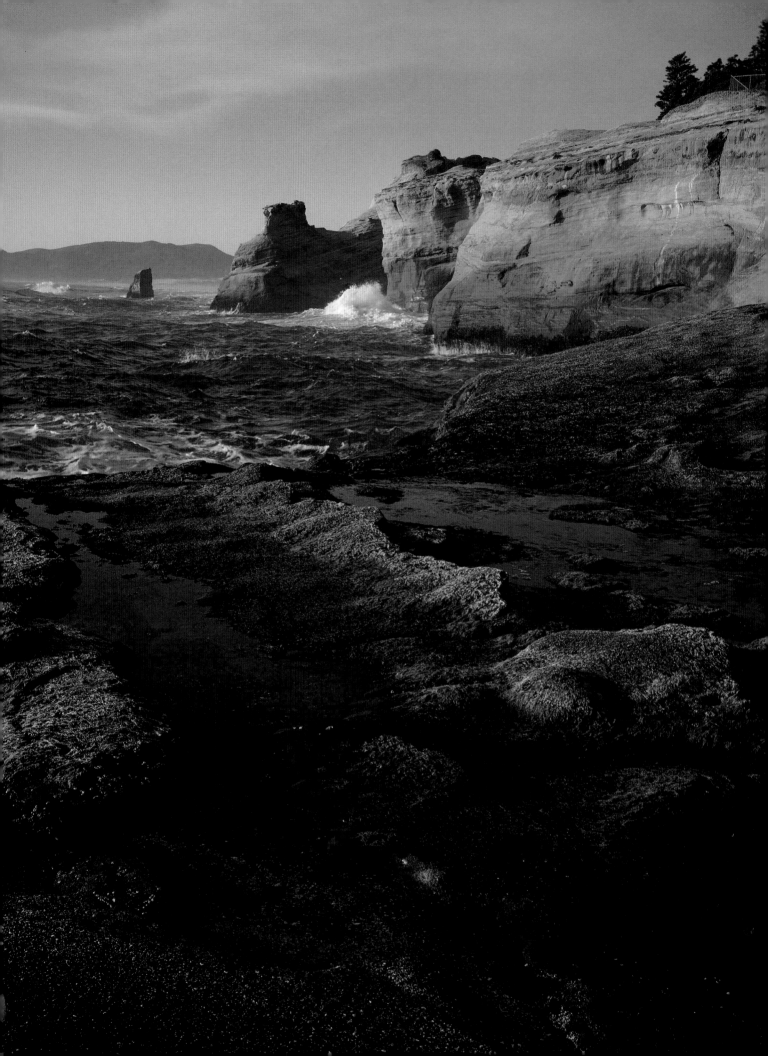

The Coast

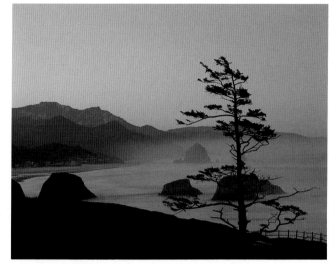

Ecola State Park and Cannon Beach

Oregon's coastline is magic, mesmerizing those who behold its expansive reaches. To some, the attraction is the way wave-cut promontories rise steeply above the shoreline; to others, it is the many offshore rocks with their jaunty, albeit ill-fitted, vegetal toupees. More than a few are captivated by the plethora of barking sea lions lolling about on wave-crashed reefs, and almost everyone is drawn to the fringe benefits of the tide—whether it be gemstones or shells or drift-log jumbles or glass floats or fragments of wrecked ships.

In its entirety, the Oregon coast is about four hundred miles long, most of it accessible to the millions who annually explore its wilds. Because Oregon long ago set aside its beaches as "public highways" to be used by the people, commercial development has been restricted. Today, close to ninety parks and waysides created by state, federal, county, and municipal governments dot the span between Brookings and Astoria, giving this rock-studded oceanfront the reputation of being "the most beautiful and most wisely developed stretch of shoreline in America."

Astoria, near the mouth of the Columbia River, is steeped in Oregon history. It was near here, in 1792, that Captain Robert Gray discovered an inlet that "extended to the NE as far as the eye cou'd reach." Naming it the Columbia, he claimed the entire drainage for the United States.

By November of 1805, the Lewis and Clark Expedition had arrived on the Pacific Coast and established Fort Clatsop, built of the "streightest and most butifullest logs" they could find. Today, their replicated fort is a national memorial about six miles southwest of Astoria.

Astoria itself began as Fort Astoria, a fur trading center on the Columbia River's south shore. Established in 1811 by New Yorker John Jacob Astor, it was the first commercial settlement and trading center west of the Mississippi River. Today, a historical marker and partially reconstructed fort are all that remain of Astoria's initial beginnings. No matter. It still holds title as the oldest settlement west of the Rocky Mountains.

Many coastal areas are rich in history. In 1846, the U.S. Naval schooner *Shark* was wrecked trying to leave the Columbia, and a chunk of its deck—cannon and capstan still attached—washed ashore near Arch Cape. What a find. Settlers pulled the flotsam ashore, set it in concrete, and named their town Cannon Beach. In 1852, gold was discovered in the sands along the south coast, and though the strike came to almost nothing, it gave Gold Beach settlers a perfect name. In 1910, the freighter *J. Marhoffer,* exploded at sea; though the captain brought the damaged vessel safely to shore, the ship's boiler floated into a nearby inlet and beached on a rocky shoal. It is still visible during low tide from the shore of—you guessed it—Boiler Bay.

In sailing days, the waters off the Oregon coast were a mariner's nightmare. Shipwrecks dictated the need for a series of sea-based warnings of offshore rocks, shifting shoals, and perilous reefs. Between 1857 and 1900, ten lighthouses took form along the Oregon coast. The sentinel at Cape Blanco, commissioned in 1870, boasted a lens visible twenty-two miles at sea. The original light still works, flashing from a fifty-nine-foot tower set 425 feet above sea level—making it not only the state's oldest operating light, but its highest.

Not even the half can be told of coastal Oregon. In the northern sector is Fort Stevens State Park, the only military installation in the continental United States to be fired on by a World War II Japanese sub. Here, too, is the Astoria-Megler Bridge across the Columbia, at four miles long, one of the nation's lengthiest continuous spans; and just further south, at Tillamook, is one of the world's largest cheese factories.

About midcoast are the world-famous Sea Lion Caves, the globe's only mainland home of Steller sea lions; nearby is a fifty-mile stretch of sand dunes that rank among the highest, most extensive, coastal dunes on earth. All up and down the bold, jagged shoreline is a succession of forested headlands, sheltered coves, towering mountains, and broad beaches that are not only primitive, but hauntingly beautiful. Little wonder coastal Oregon remains one of the West's great spectacles.

◄ *Cape Kiwanda State Park*

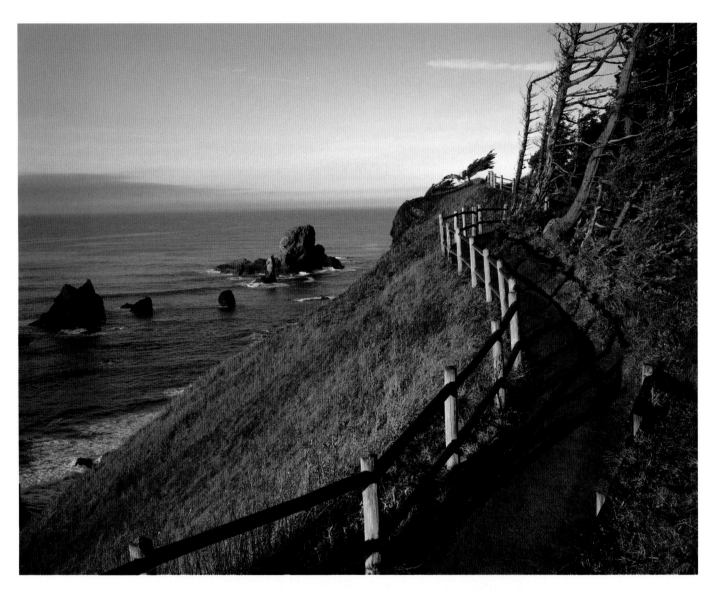

▲ Ecola State Park encompasses some thirteen hundred acres and claims one of coastal Oregon's most magnificent views. ▶ Hug Point State Park, on Cannon Beach, was so named because it was necessary to hug the rocks to get around the point without risking a dousing. Before U.S. 101 was built, wagons and automobiles used the beach as a highway, so the county cut a road into the side of Hug Point's rocky ledge. The narrow road now serves as a trail rather than a highway.

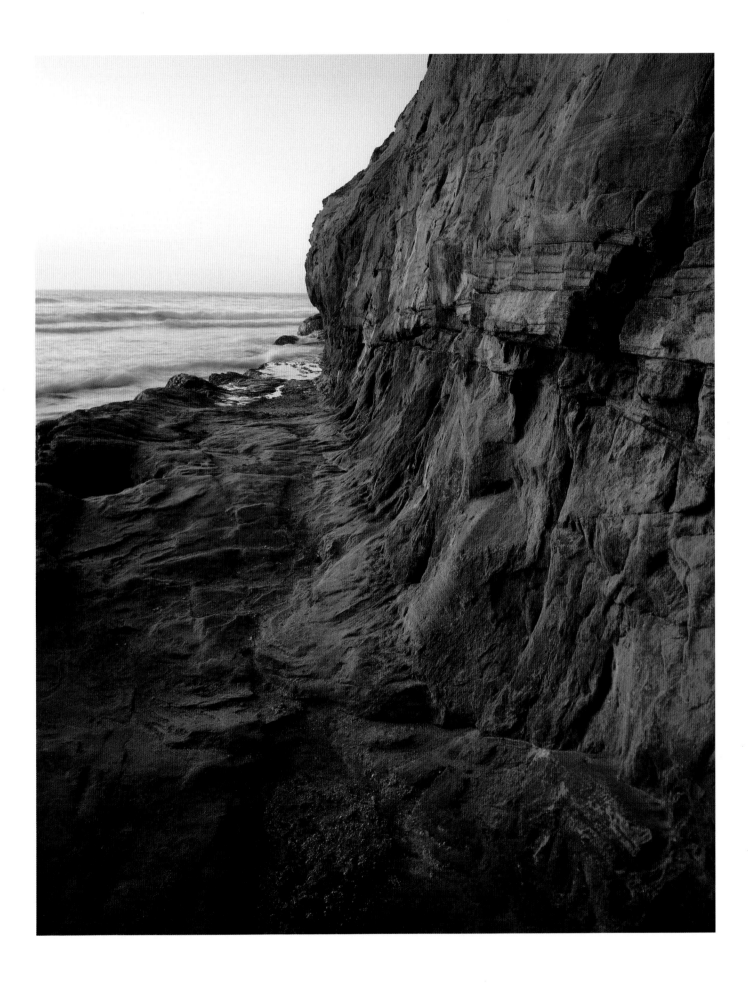

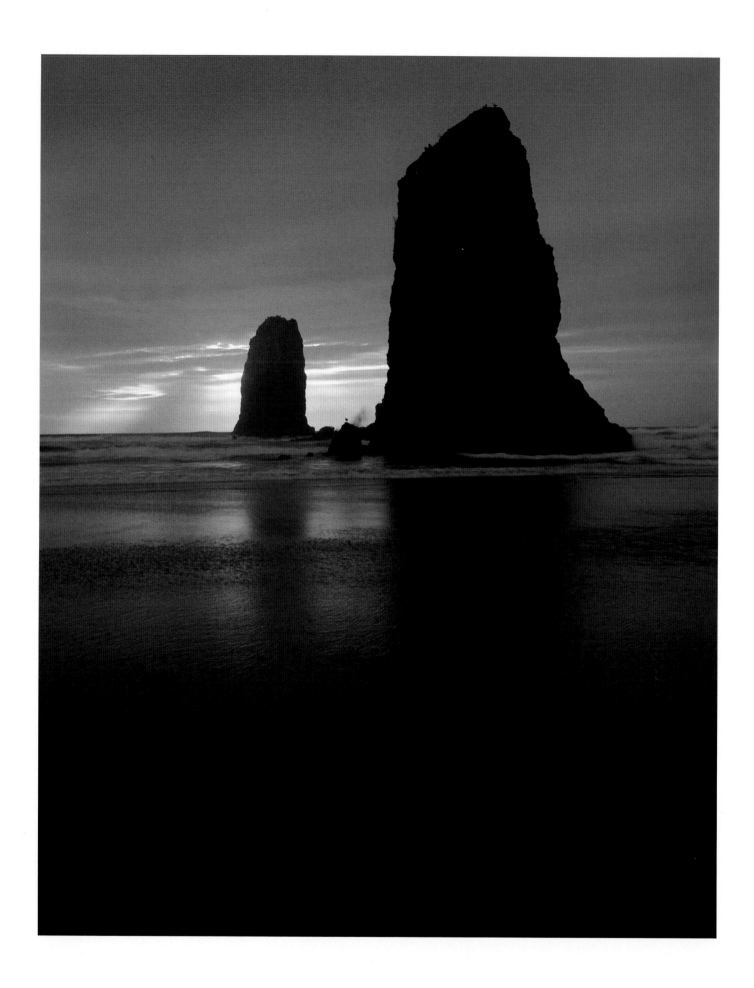

◄ The Needles at Cannon Beach rise out of the Pacific like leviathan fins. Offshore rocks along the Oregon coast are common, though few are as distinctively shaped as these.
▲ Eight-mile-long Cannon Beach, now a seaside resort, was named for a ship's cannon that washed ashore in 1846.
►► Ecola State Park takes its name from the Chinook word, *ekoli,* meaning whale, and was bestowed by Captain William Clark after seeing Indians cutting up a whale on the beach.

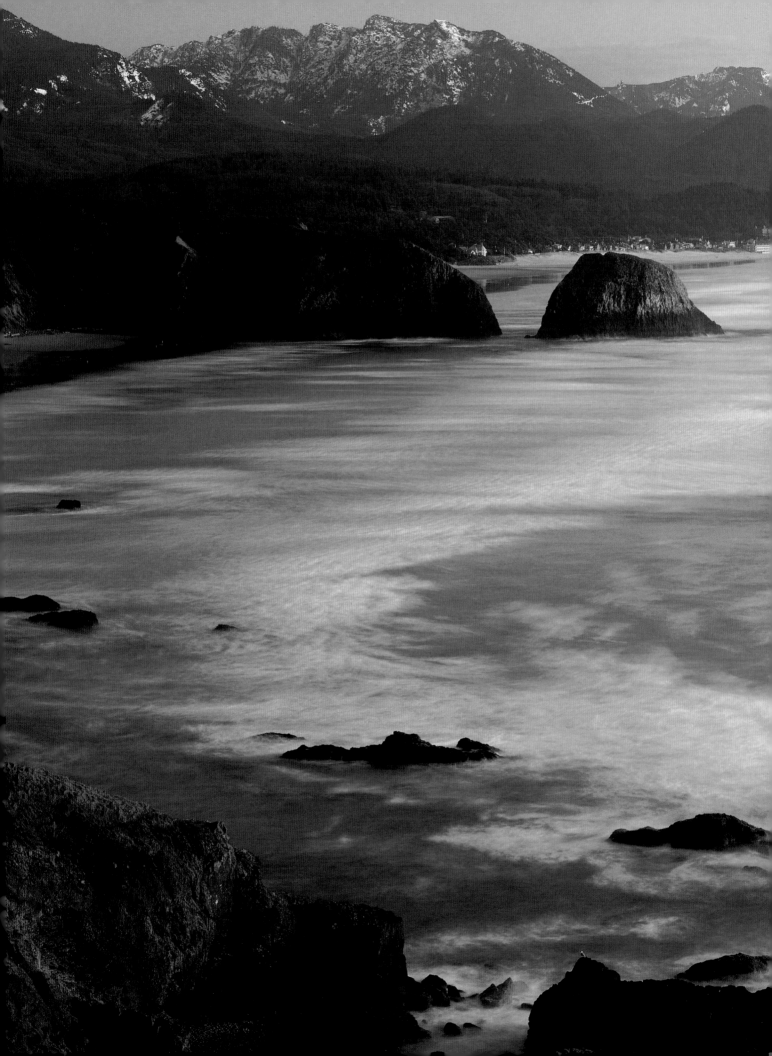

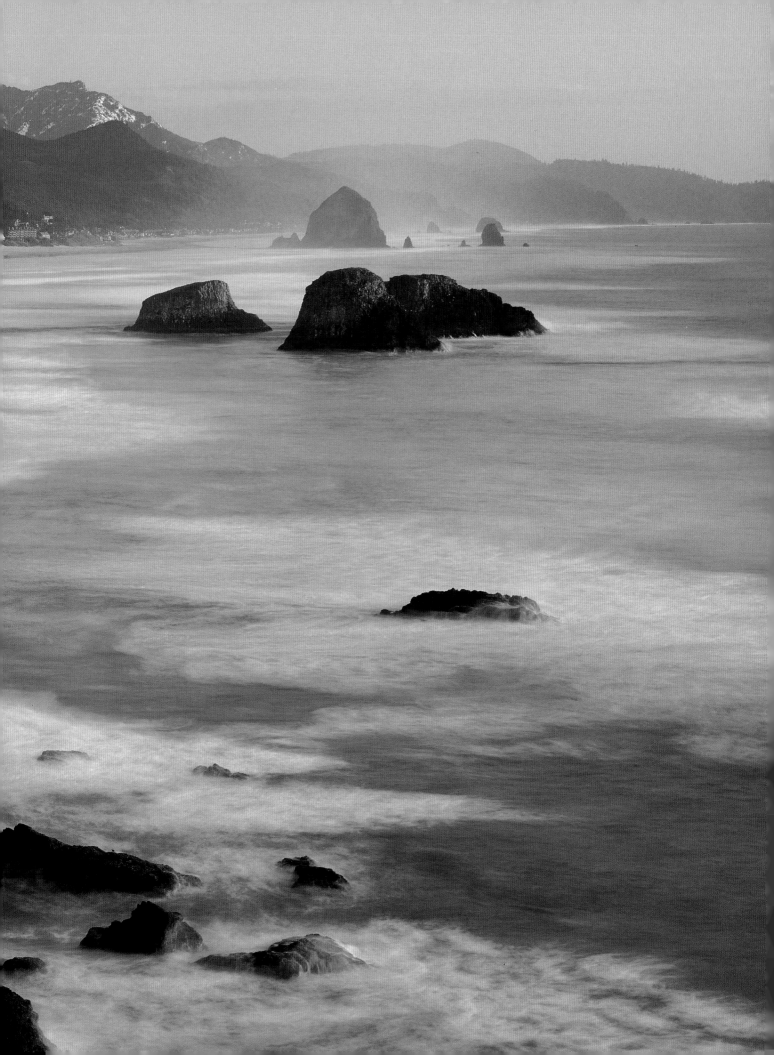

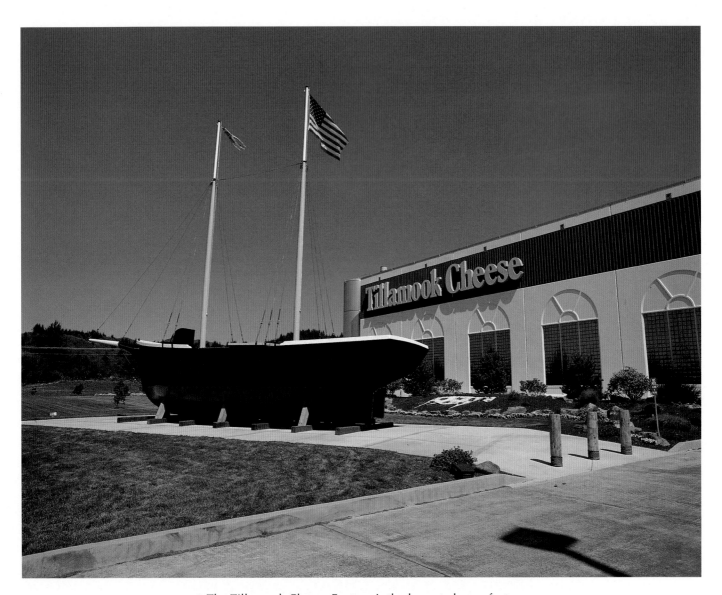

▲ The Tillamook Cheese Factory is the largest cheese factory on the coast and one of the largest in the world. Oddly enough, it is one of Oregon's top three tourist attractions. Oregon cheese is known world-wide for its quality and flavor, mostly because the coast's mild climate and green pastures enable the cows to produce milk ideally suited for cheese.

▶ The Little Nestucca River flows into the ocean at Pacific City and is well known for its runs of salmon and steelhead.

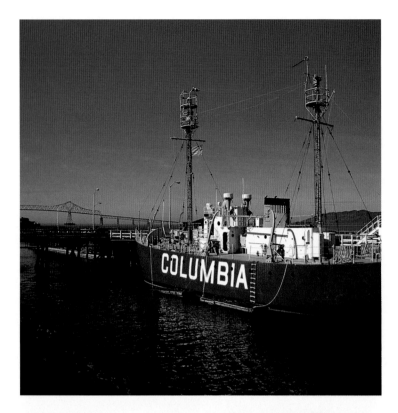
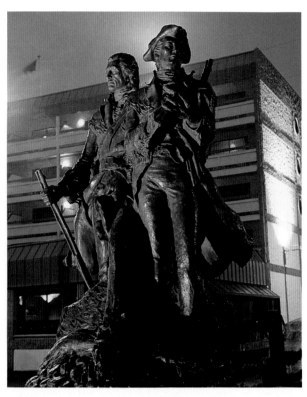
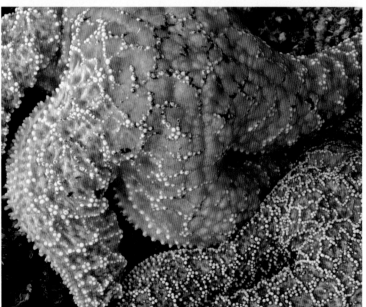

Clockwise above: • In 1889, Congress appropriated $60,000 for Columbia River Lightships; the last lightship on the river was *LS #604,* now on display at Astoria's Columbia River Maritime Museum. • This statue in Seaside marks the end of the Lewis and Clark Expedition's trail, which began in 1804 in Missouri. • Thousands of small beach cottages are tucked along Oregon's coast. • Sea stars, often mistakenly referred to as starfish, are tidepool bullies, fighting over tasty tidbits.

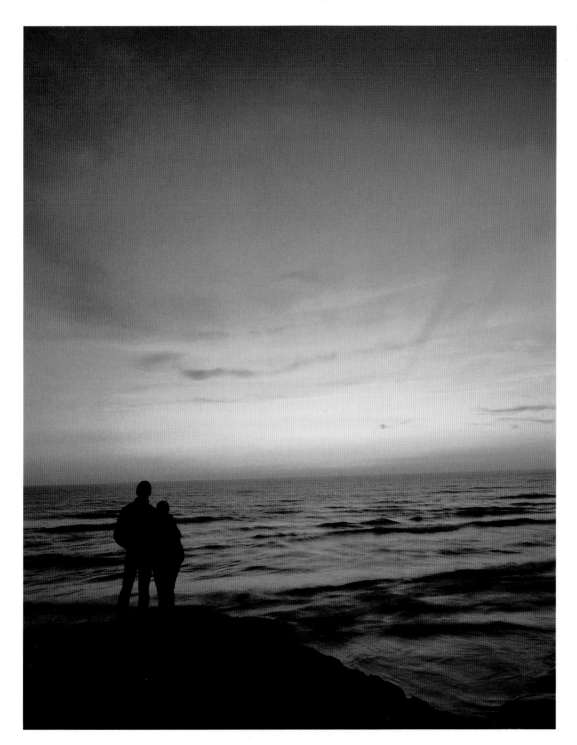

▲ Ocean sunsets emanate a becalming factor that is medicine to a weary soul, and eventide brings out all kinds of onlookers such as these at Nye Beach in Newport, who come here for nothing more than a few moments of quiet togetherness.

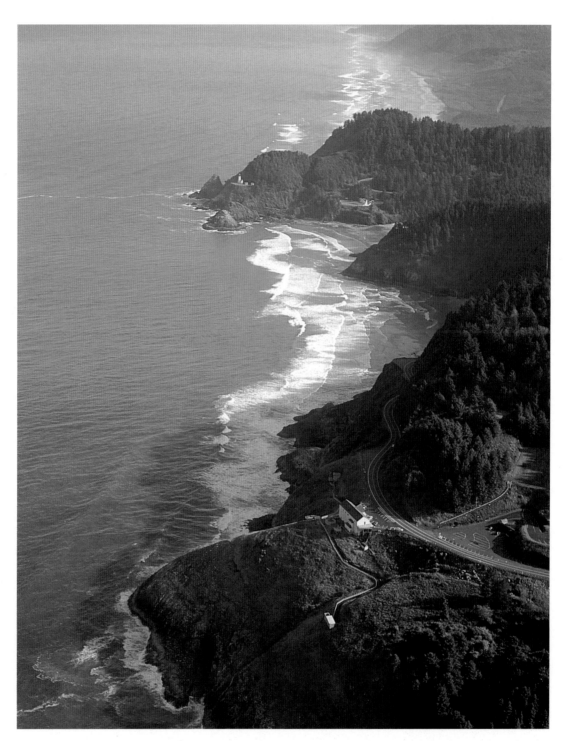

▲ The Heceta Head Lighthouse is visible from northbound Highway 101 as well as the nearby Sea Lion Caves. It was commissioned in 1894 with a first order lens from England. Visible twenty miles at sea, the light blinks every ten seconds.

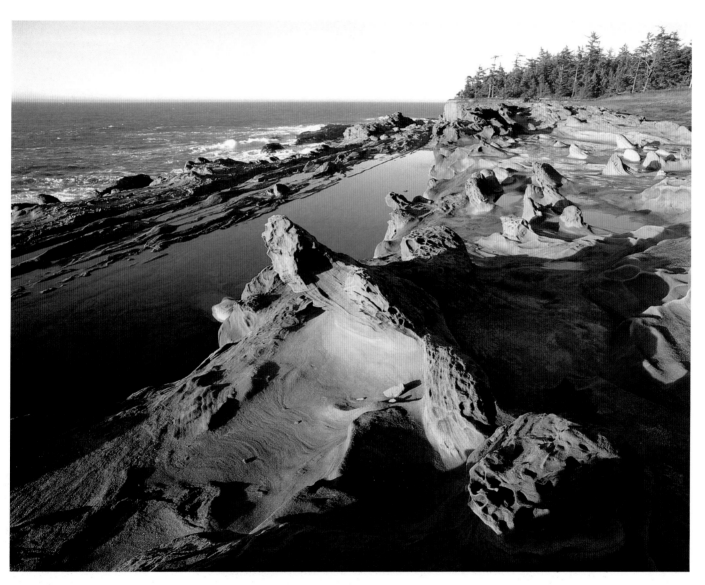

▲ The fifty-foot-high sandstone sea cliffs of Shore Acres State Park south of Charleston have been eroding for millions of years and are a beguiling hodgepodge of formations that would seem more at home on the desert than along the coast.

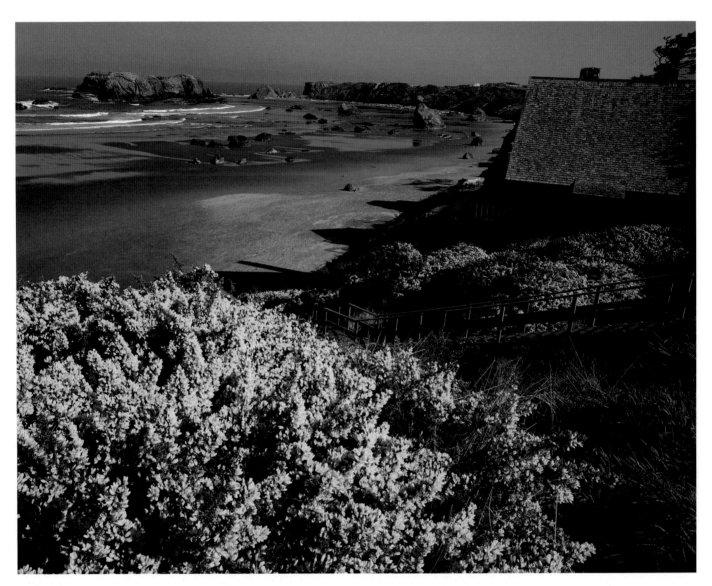

▲ Bandon's wide, sandy beaches are uncrowded; the dunes are overlaid with all manner of flowering plants; and the off-shore rock formations are quite accessible during low tides.
► In 1888, Congress appropriated $50,000 for a lighthouse near the mouth of the Umpqua River. The original, built in 1855-57, was the first lighthouse in Oregon Territory, but in 1861, it was toppled by river freshets and encroaching seas. The current lighthouse was built between 1891 and 1894.

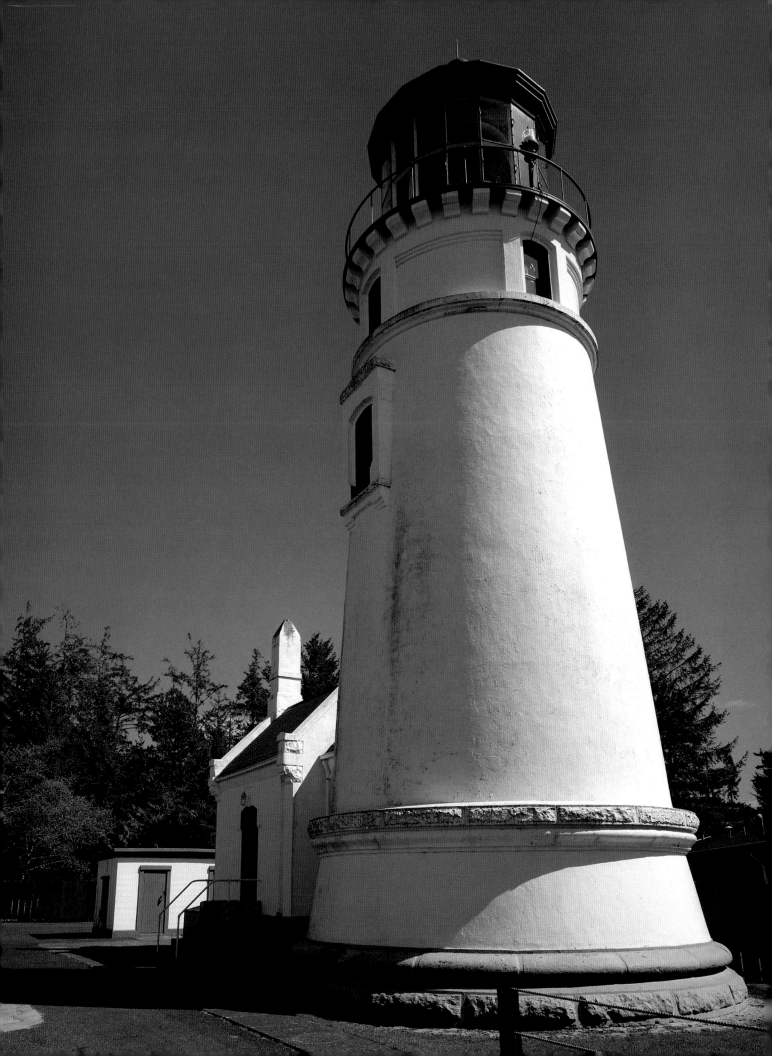

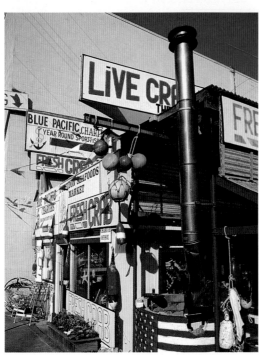

Clockwise above: • Honeyman State Park encompasses 522 acres and is noted for its coastal sand dunes. Water sports are popular on the park's three lakes: Woahink, Cleawax, and Lily. • The Oregon Coast Aquarium on Newport's Yaquina Bay helps visitors understand the coast's diversity and fragility. • Newport claims to be the "Dungeness Crab Capital of the World." • Yaquina Bay's docks are lined with restaurants touting crab, shrimp, salmon, and oyster specialties.

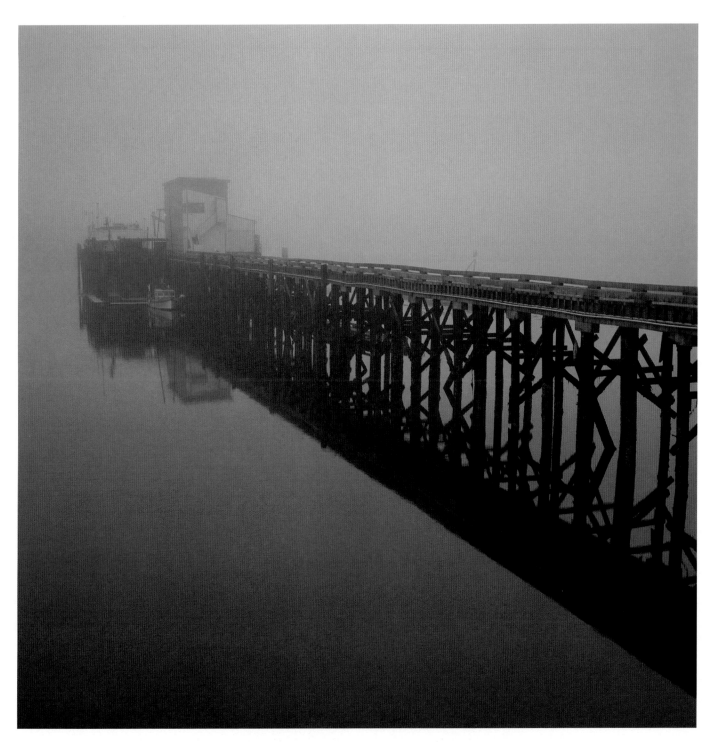

▲ Charleston, at the mouth of Coos Bay, is one of Oregon's three main commercial fishing towns. It is also the state's largest commercial fish packing center—canning or cold-packing tuna, salmon, shrimp, crab, bottom-fish, and oysters.
▶ ▶ One of Seal Rock State Park's most notable attractions is Elephant Rock. The mammoth chunk of basalt, along with its accompanying offshore rocks, was actually created by an underground lava flow about fourteen million years ago.

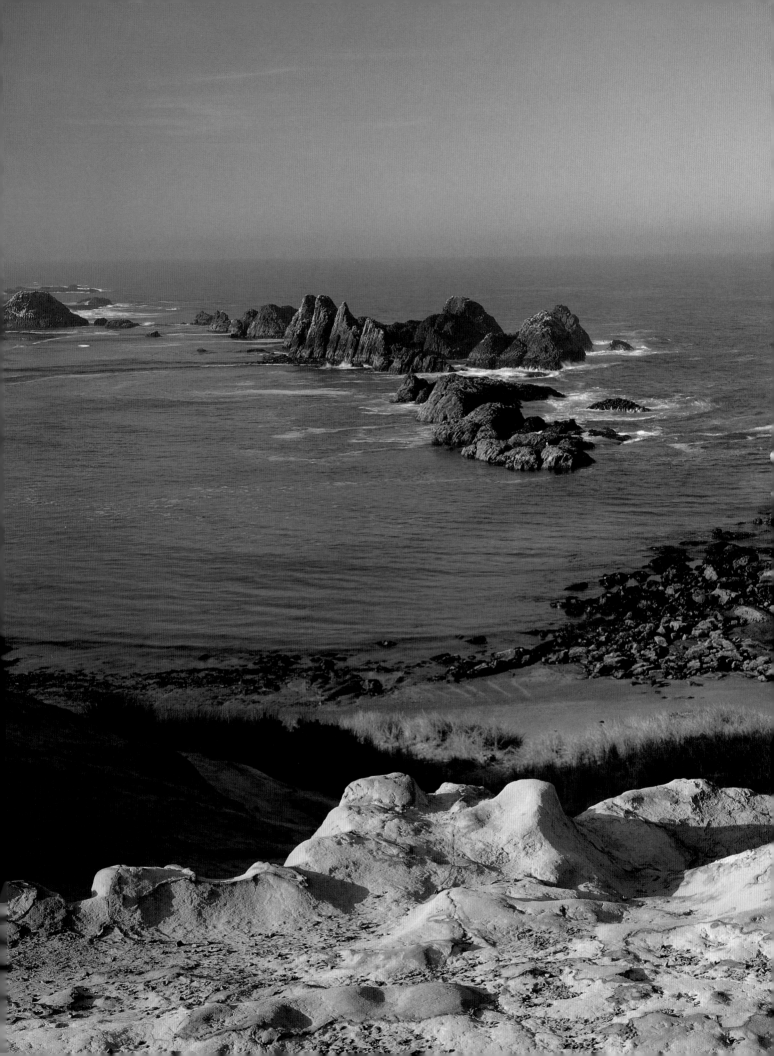

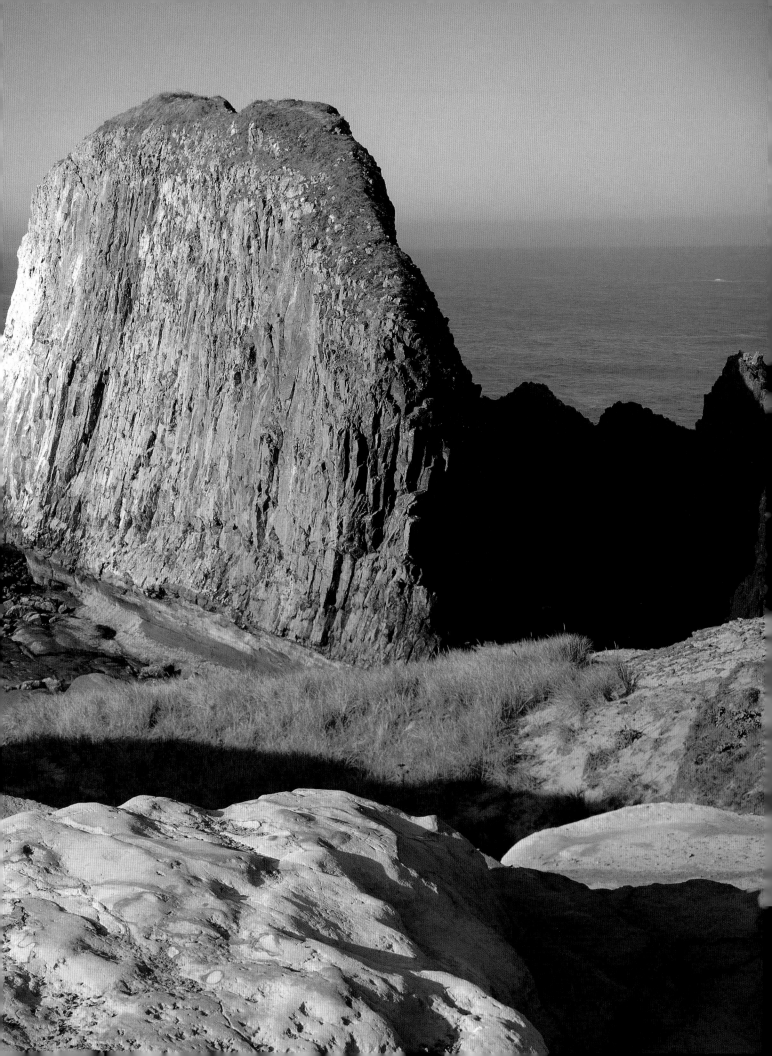

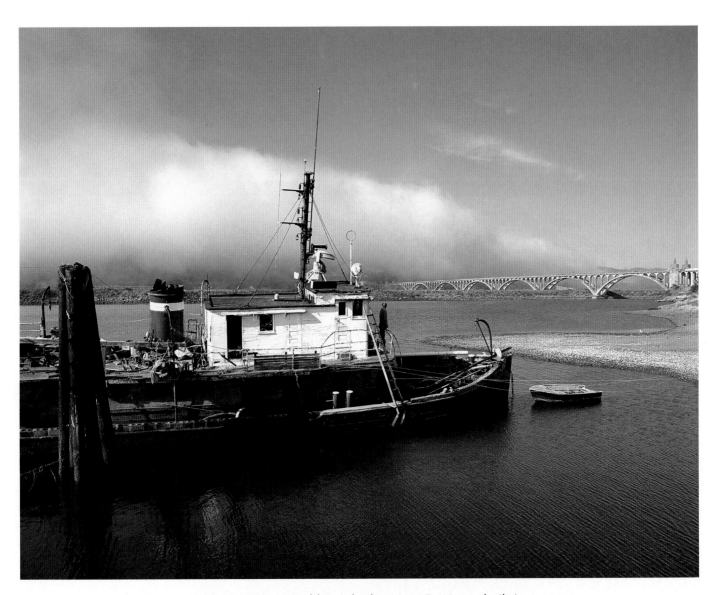

▲ Now resting at Gold Beach, the *Mary D. Hume*, built in 1880, was once used as a whaling ship in the Bering Sea.
▶ The Battle Rock Wayside near Port Orford commemorates the battle between the men of the steamer *Seagull* and the Rogue Indians. In 1851, Captain William Tichenor landed men and provisions here, with plans to establish a townsite. The Rogue Indians had other ideas and besieged the party. After several days' fighting, the men stole away to safety.

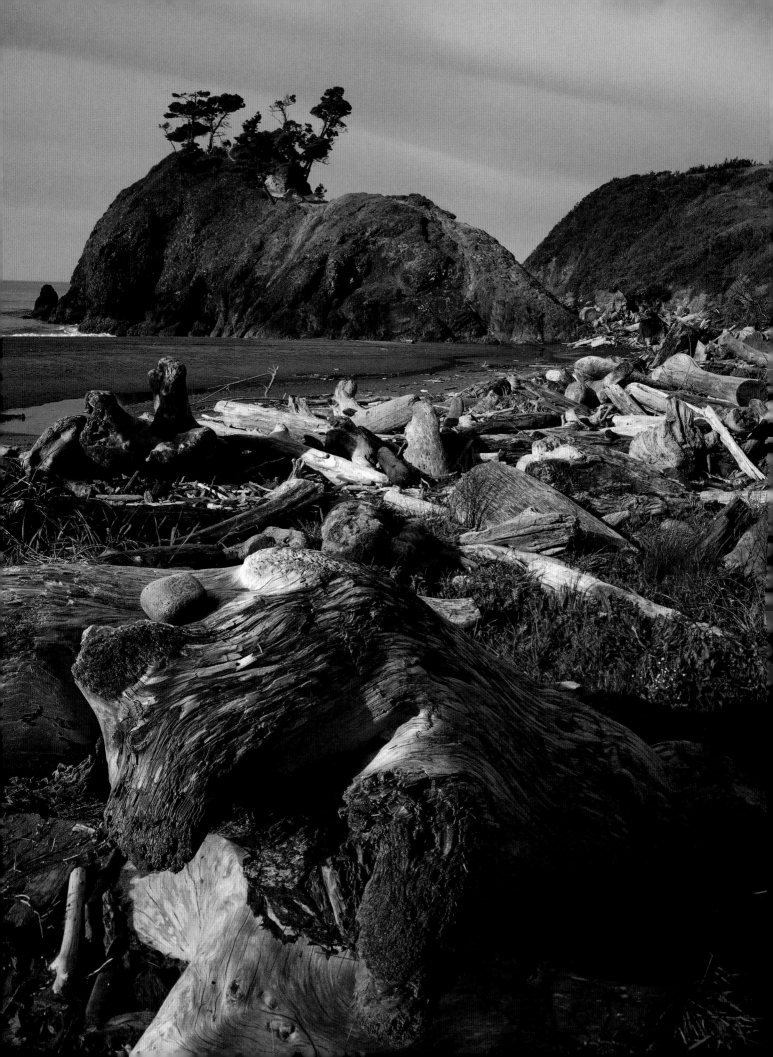

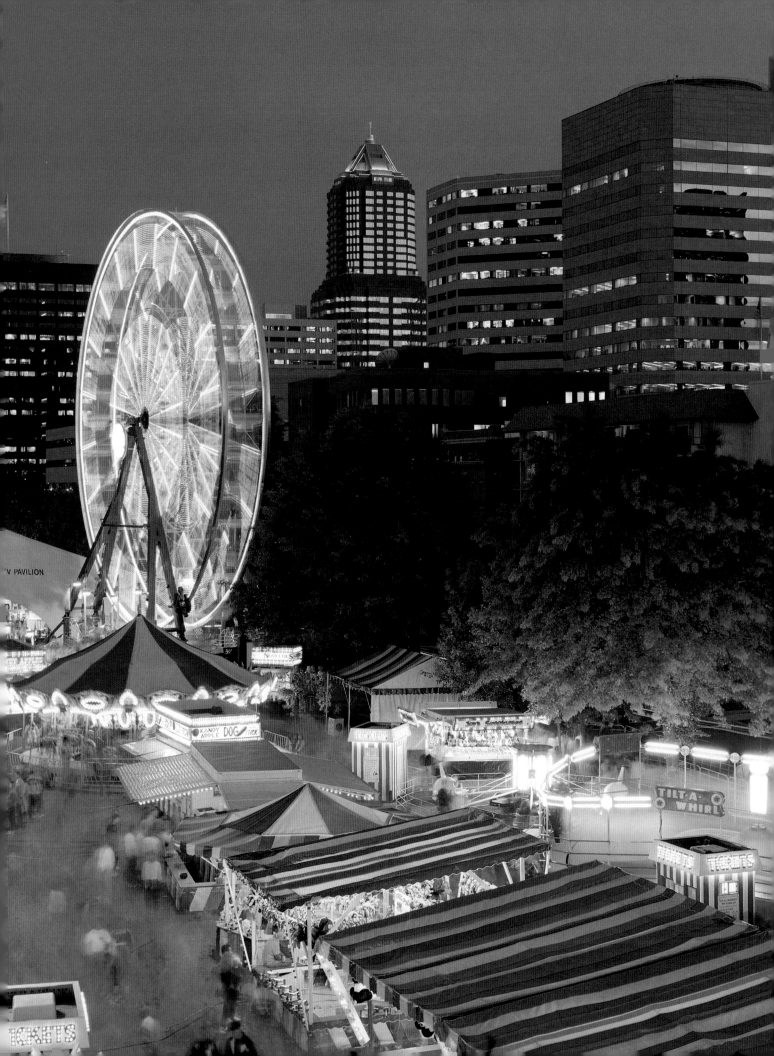

Portland & the Western Valleys

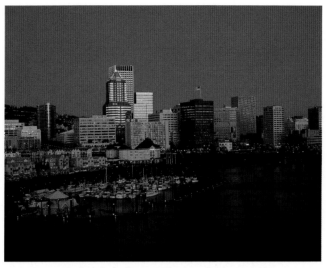

Portland skyline and waterfront marina

They called it Stumptown. It was an ignoble name for any settlement, even if the many tree stumps left standing in and around the cabin clearing did represent an obvious title. Chances are, the name would have been changed, even if two New England emigrants had not taken the winters of 1844 and 1845 to clear land to lay out a sixteen-block townsite on the Willamette River's west bank. Then, each wishing to name the town after a city in his home state, they tossed a coin. Two out of three tosses went to the man from Maine.

So Portland was born. The townsite, bound on the north by the Columbia and split by the Willamette, grew to be the state's largest city. Little wonder. It was a place where settlers from all around could come for goods, hospitality, and to meet the many ships plying the two rivers. By 1852, Portland claimed about seven hundred inhabitants. By 1858, it had grown to encompass one hundred stores, countless homes, and a population of two thousand. Today, the city straddles both sides of the Willamette, stretches east toward Mount Hood, and claims a citizenry of 1.5 million in the metro area alone, and another 453 thousand inside city limits. It has also given itself a noble nickname: City of Roses.

Portland has gone out of its way to put the Stumptown legend to rest forever. The city claims 280 parks and gardens covering 37,000 acres of urban wilds. Forest Park alone spreads across nearly 5,000 acres, making it the nation's largest forested municipal park. Washington Park's 322 acres are divided into sites such as Hoyt Arboretum whose 700 varieties of trees and shrubs comprise America's largest conifer collection; the International Rose Test Gardens, nearly 5 acres of terraced rose bushes that make up the oldest agricultural test plot in the country; and the Metro Washington Park Zoo, 61 acres recognized worldwide as housing the planet's most successful captive Asian elephant breeding program.

Stretching south from Portland all the way to the California border are Oregon's great agricultural valleys named for the rivers that run through them: Willamette, Umpqua, Rogue, and Illinois. The Willamette Valley, nearly 120 miles long and 10 to 20 miles wide, was the goal of most who followed the Oregon Trail west. Not surprising. Tales of the valley were legion. ". . . The soil is so fertile you don't even have to plant the wheat, it just comes up year after year all by itself." Or "gentlemen, they do say that out in Oregon the pigs are running about under the great acorn trees, round and fat and already cooked with knives sticking in them so that you can cut off a slice whenever you are hungry. . . ."

Between 1840 and 1860, more than fifty-three hundred immigrants spread south down the valleys. They built homes, schools, and churches; planted orchards and wheat fields; established industry and governments; and in the end, left a footprint on the land still visible today. Oregon City, the state's first seat of government, boasts some of the finest nineteenth-century buildings in the state. Champoeg, midway between Portland and Salem, preserves the site where more than one hundred French-Canadian and American settlers met in 1843 to establish Oregon Country's first provisional government. Mission Mill Village in Salem claims the Jason Lee House, built in 1841, making it the oldest frame house in the Pacific Northwest. The whole town of Jacksonville, settled in 1851, has been declared a National Historic Landmark—one of only eight cities in the United States set aside as such.

Scattered throughout the Willamette and Umpqua valleys are covered bridges, "folk architecture" so charming tourists drive miles just to see them. Covered bridge building here dates back to 1851 when an existing bridge in Oregon City was roofed over. Then followed a bridge-building heyday, and by the time it was over, there were more than three hundred gracing Oregon's roads. Approximately fifty still stand—more than any other state west of the Mississippi.

Perhaps Oregon's beginnings are still so visible not only because its history lies so close to the surface of the land, but because the descendants of those "lank, lean, hungry, and rough" pioneers have worked to preserve it. From Portland to California is a living history museum—a time warp of the past set amidst the neon of the future. Somehow it all works.

◄ *Portland's Rose Festival*

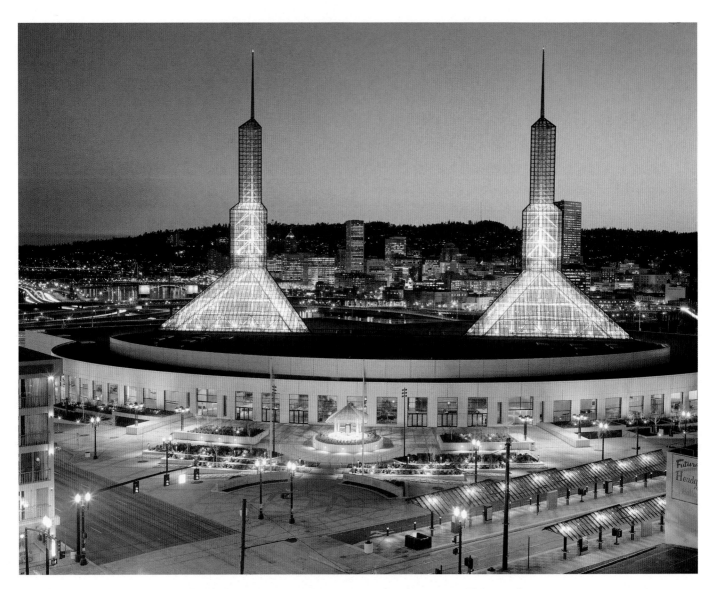

▲ The Oregon Convention Center boasts twin 150-foot-tall glass and steel towers. The south tower claims a Chinese dragon boat; the north tower, a bronze Foucault pendulum.
▶ Washington Park was designed by the Olmsted Brothers who created New York's Central Park and San Francisco's Golden Gate Park. The park includes a world-renowned zoo, rose gardens, and a Japanese Tea House. Perhaps most spectacular is the view across the city, all the way to Mount Hood.

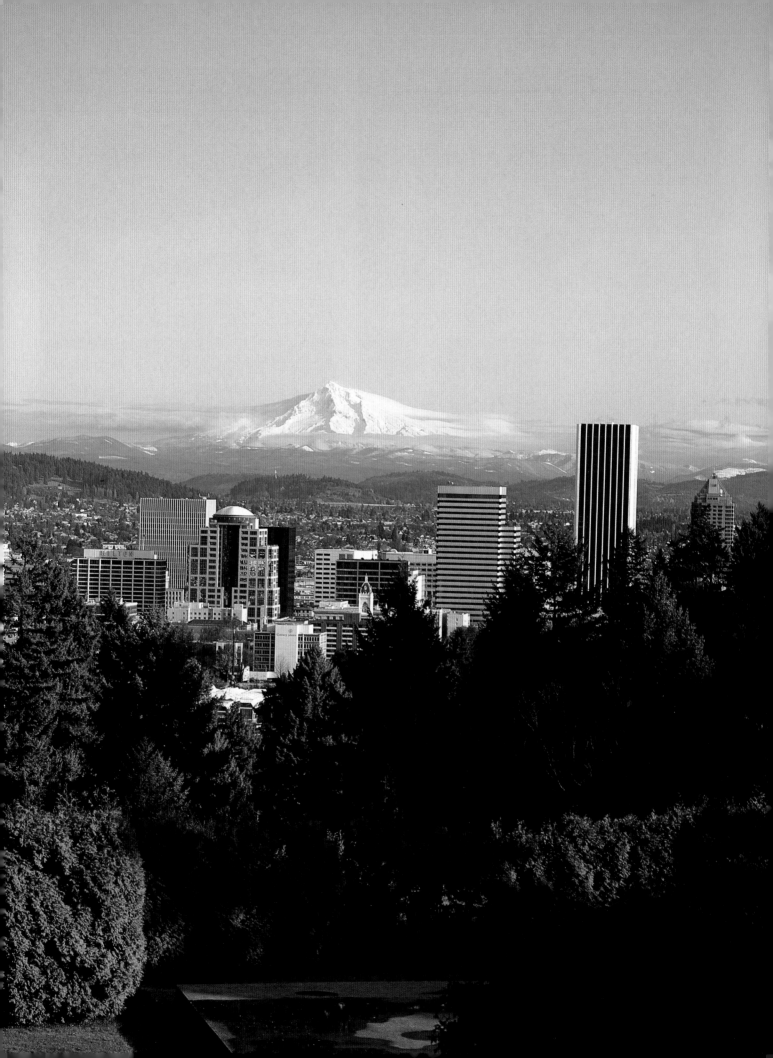

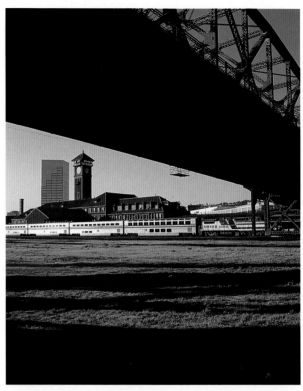

Clockwise above: • In Oregon, a little rain seems to bother no one. • Old Town's Union Station, built in 1894, is listed in the National Register of Historic Places. • Established in 1887 and covering sixty-one acres, the Metro Washington Park Zoo contains settings with habitats ranging from Alaskan tundra to African veldts. • The interactive exhibits at the Oregon Museum of Science and Industry, better known as OMSI, inspire exploration of computers, space, and earth sciences.

▲ The Willamette and Umpqua valleys' fertile soil and ocean-tempered climate provide a long, warm growing season that is ideal for the cultivation of many wine grapes and berries. Oregon wineries are generally small and widely scattered and are usually family-owned. Some sixty wineries are open to the public, with spring being the favorite time for visiting.

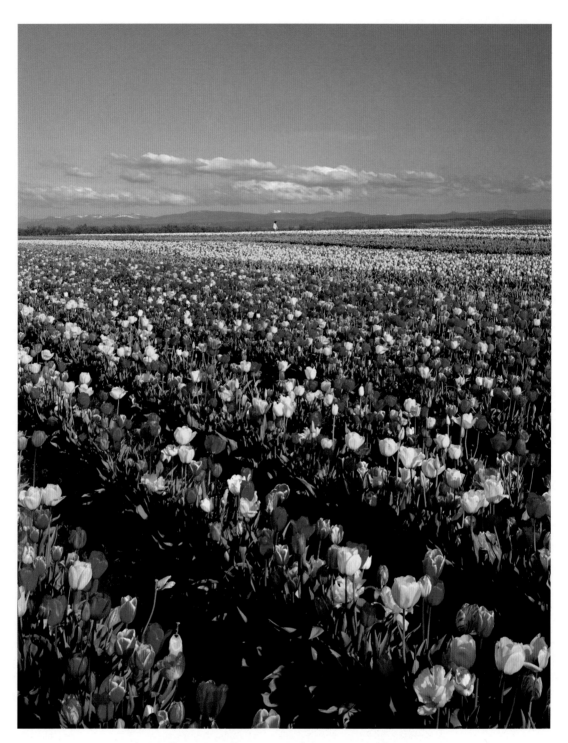

▲ The Willamette Valley is one of the most productive agricultural valleys in the world. The fertile land yields a wide variety of crops—from wheat to nuts and strawberries to beans. Many acres are given over to bulb plantings like those at the Iverson Wooden Shoe Tulip Farm in Mount Angel.

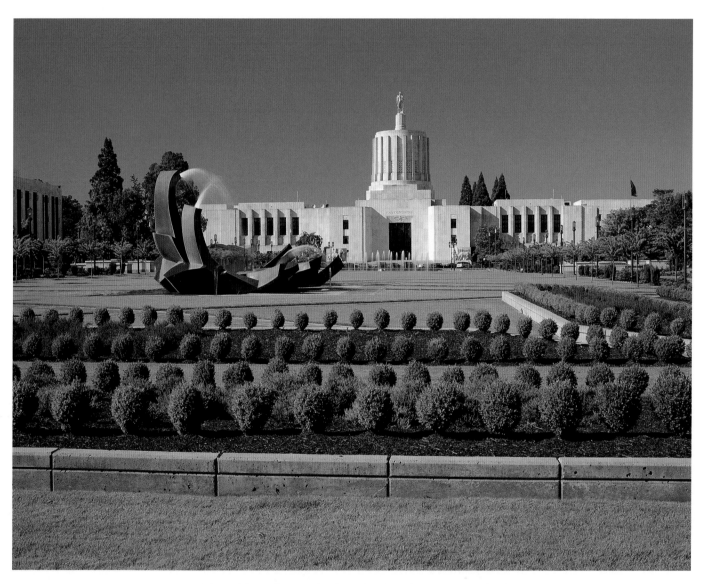

▲ Salem, fifty miles south of Portland, is the state capital. The capitol building, constructed in 1939 of Vermont marble, is topped by a twenty-four-foot statue of an Oregon pioneer. Surrounded by an exquisitely manicured park, the capitol is patrolled by some of the most brazen squirrels on the planet.

▲ The Hult Center for the Performing Arts—claiming the best acoustics of any concert hall on the West coast—is in Eugene, considered the cultural capital of lower Willamette Valley.
▶ The Shimanek Covered Bridge, 130 feet long, was built in 1966. It is the fifth bridge to span this section of Thomas Creek just outside Scio. The first bridge was built in 1861, with others following in 1904, 1921, and 1927. All met with the same fate, whether from high water, falling trees, or damaged piers.

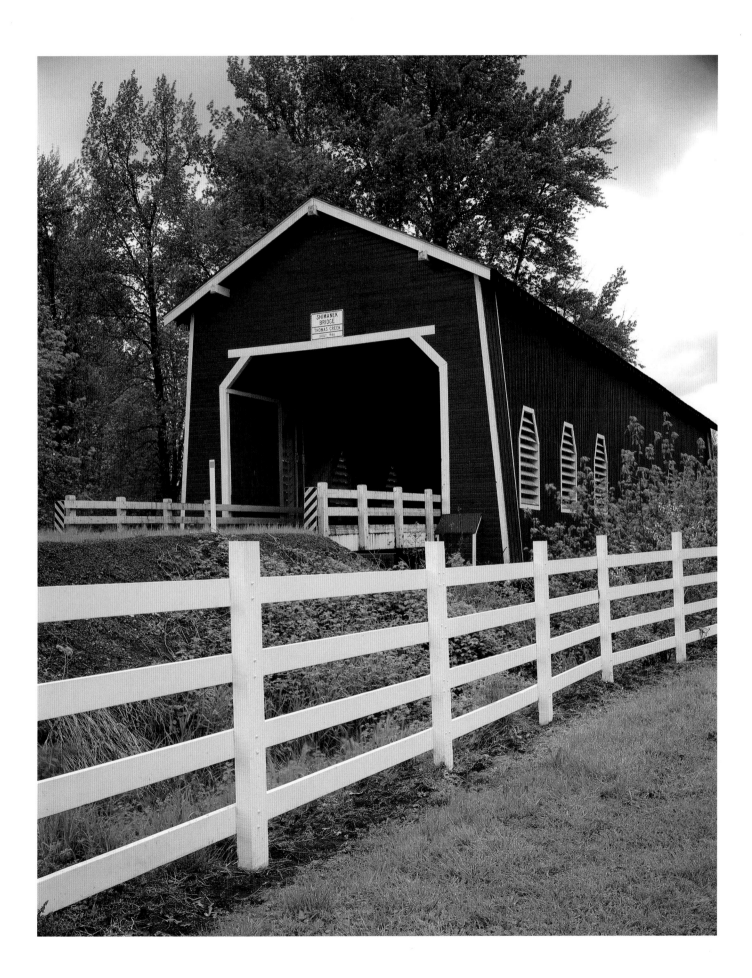

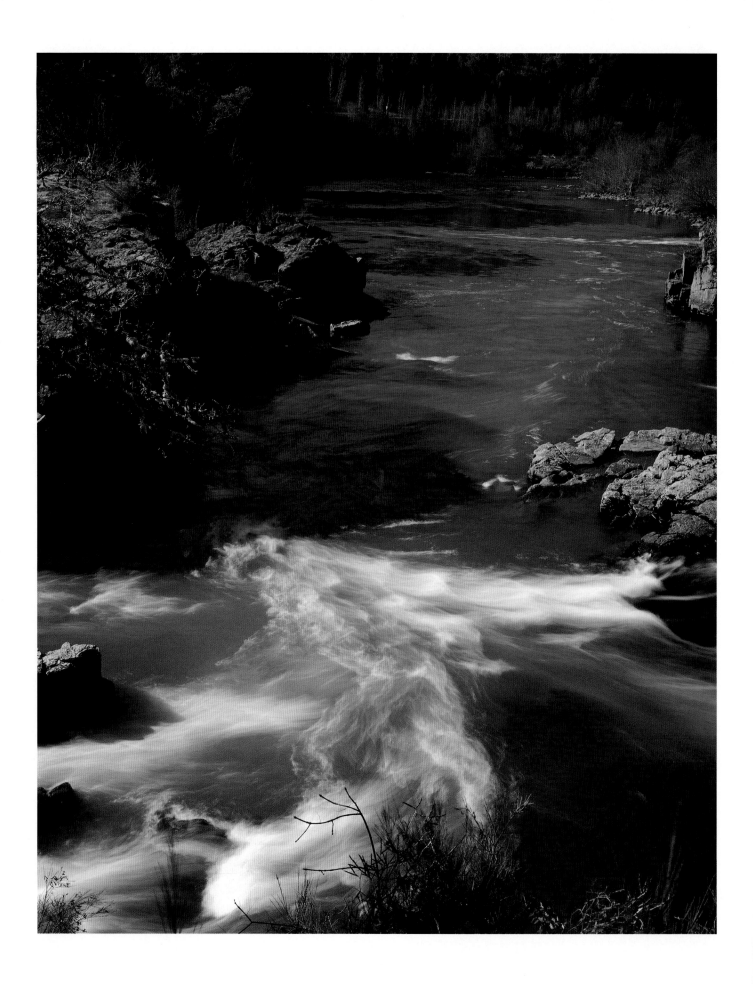

◄ A rare phenomenon, the North Umpqua and Little rivers meet head-on before continuing together in a new direction.
▲ Miss Annie Gaines became known in hiking circles when, in 1865, she and a female companion were the first two white women to hike down to Crater Lake. Later, Annie Creek, in the southern Cascade foothills, was named in her honor.

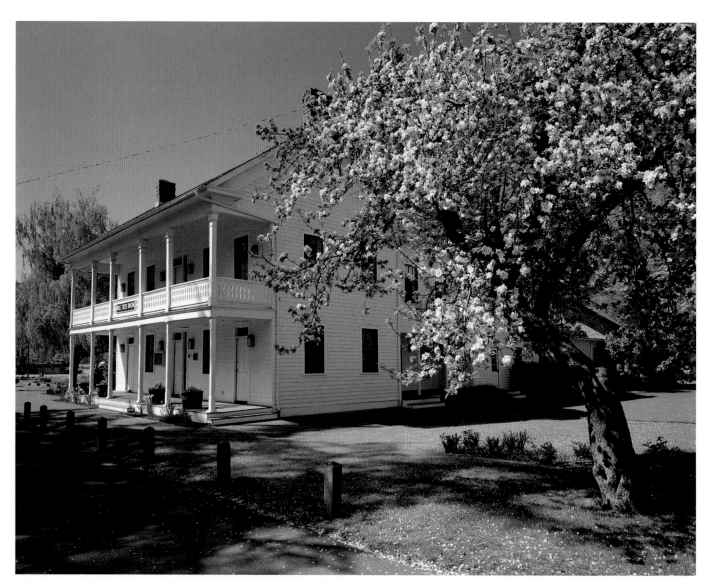

▲ Wolf Creek Tavern dates from the stagecoach days of the late 1800s. It is thought to have been built around 1873 and has been operated as a wayside inn to the present. In 1975, the Oregon State Parks and Recreation Division acquired the tavern and, after renovation to historic records, has continued to operate it as a restaurant, hotel, and banquet facility.
▶ A rapeseed by-product raised experimentally near Medford, canola oil is lowest in saturated fats of leading cooking oils.

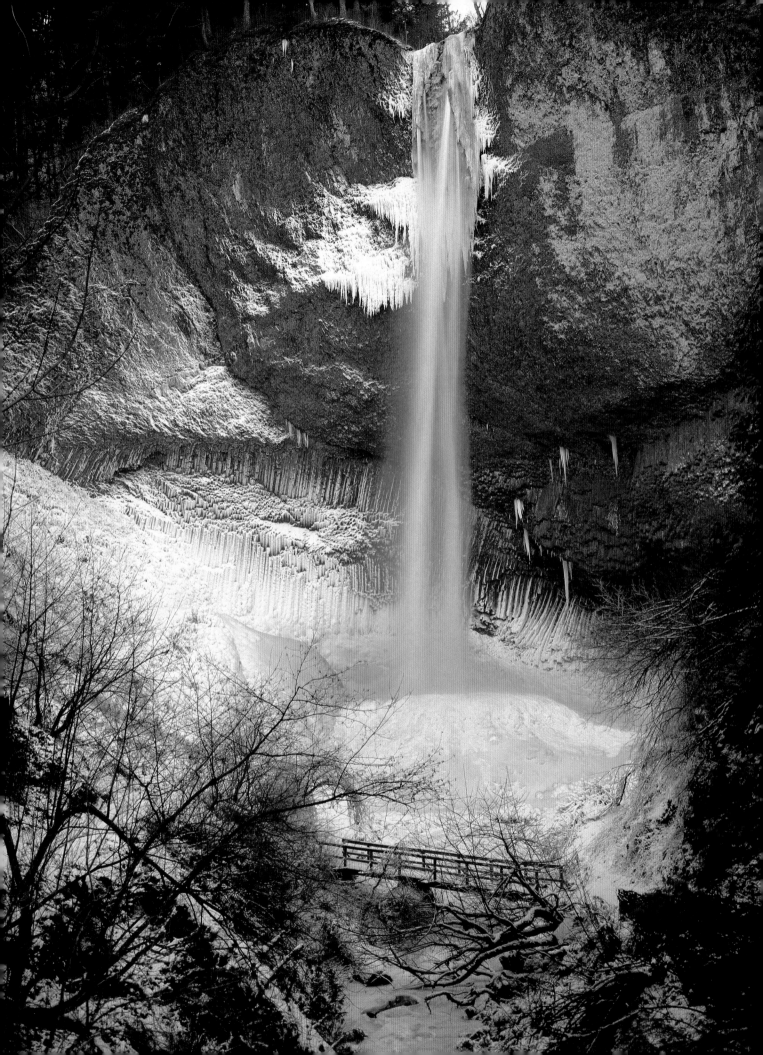

Columbia River Gorge

Shepperd's Dell State Park, along the Historic Highway

It was a wild river born in British Columbia. Second only to the Mississippi River in volume and seventh in length of all U.S. rivers, it ran south through Canada, then east to Washington, and somewhere along its 1,243-mile journey to the sea, it turned west to form the Washington-Oregon border. Sometimes the river flowed swift and silent; other times it churned itself into a frothing frenzy. But nowhere was its performance more dramatic than within an eighty-mile-long-canyon known today as the Columbia River Gorge.

It is one of the most spectacular sights on the American earth. Here, where the Columbia River has cut through the volcanic basalt of the Cascade Range to form a natural east-west route, is a place so unique that in 1986 nearly three hundred thousand of its acres were set aside as the Columbia River Gorge National Scenic Area. In general, the Gorge extends from Troutdale on the west to the Deschutes River on the east, and in between are sheer cliffs, daredevil waterfalls, shaded canyons, piney forests, deep-cut chasms, windswept plateaus, and mind-boggling river vistas.

Archeological evidence reveals that man has lived in the Gorge for the past twelve thousand years. So abundant were the salmon, berries, deer, elk, bear, and edible plants that prior to European settlement, this was the most densely populated area of what is now the United States. Lewis and Clark, during their 1805-06 expedition, noted that the river banks, from Cascades (now Cascade Locks) to The Dalles were lined with Indian longhouses. And even though only a few place names remain to remind us of the Native American era, the Gorge is a veritable history book of white man habitation.

The chronicle begins at The Dalles. First on the scene were the explorers and fur traders, then came the missionaries, then the Oregon Trail emigrants, and then the army. Between 1843 and 1846, The Dalles was the end of the Oregon Trail wagon route, for it was here, at the place French voyagers had named La Grande Dalle de las Columbia, that the river jammed itself into such a narrow basaltic trench that its waters screamed downstream at thirty feet per second. Faced by the sheer cliffs of Rowena crest on the land side, and the river on the other, the emigrants were forced into what came to be known as "The Decision at the Dalles."

Some built rafts or barges, taking their chances on the river. Others, too impoverished or tired or so stunned by seeing their companions' rafts torn asunder by the dangerous currents, decided to call The Dalles the end of their trail. Such was Henderson Luelling, who packed seven hundred vines, shrubs, and fruit trees, then struggled to keep them alive during the two thousand-mile trip. His efforts resulted in the Gorge becoming a major producer of apples, cherries, and winter pears.

In 1846, an enterprising emigrant, Sam Barlow, carved out an eighty-five-mile toll road from The Dalles, around Mount Hood's southern flank, to Oregon City in the Willamette Valley. It was steep, treacherous, and costly: five dollars per wagon and one dollar per head of livestock. Too much for some emigrants' pocketbooks. So, The Dalles grew. By the 1850s, the community boasted two dry-good stores, a spattering of houses, a blacksmith shop, a wharf to handle both large flatboats and shallow-draft steamboats, and the only military stronghold between Fort Laramie and Fort Vancouver. By the 1860s, with gold discovered in nearby Idaho, The Dalles became an important trading center, and later became the largest Columbia River city east of Portland.

By the early 1900s, as communities increased along the river edges, a highway through the Gorge seemed necessary. By 1916 it was a reality. Heralded as a great engineering feat, the highway hairpinned through some of the Gorge's most spectacular scenery, displaying dry masonry walls and viaducts fashioned by Italian stonemasons, rubble parapets with arched openings, and windowed tunnels blasted through solid rock. The Northwest's first paved road was so beautiful the *Illustrated London News* reported, "It is the king of roads." Although only one-third of the highway's original seventy-three miles remains drivable, the "king of roads" still winds through what many called the grand dame of gorges.

◄ *Latourell Falls*

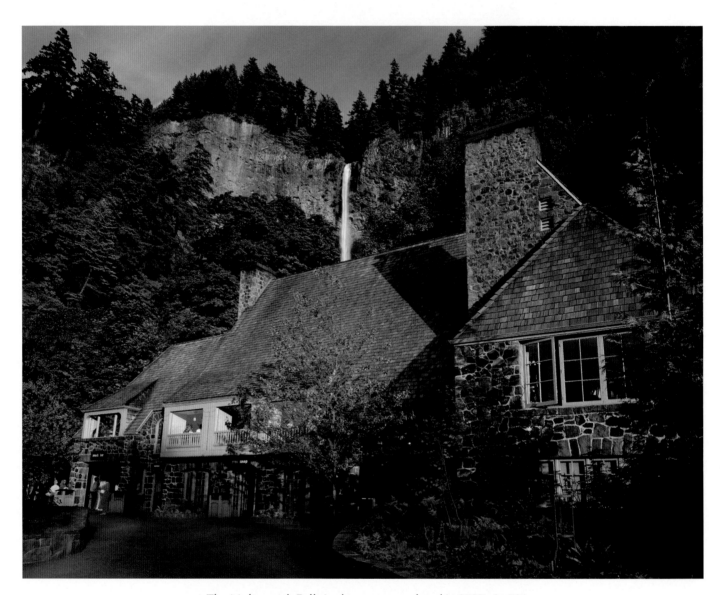

▲ The Multnomah Falls Lodge was completed in 1925. At 620 feet high, the falls are the tallest in Oregon and fourth highest in America, attracting some two million visitors each year.
▶ The 733-foot-high Crown Point was designated a National Natural Landmark in 1971. Perched atop the Point is Vista House, built in 1917 as a memorial to Oregon Trail pioneers, and now listed in the National Register of Historic Places.

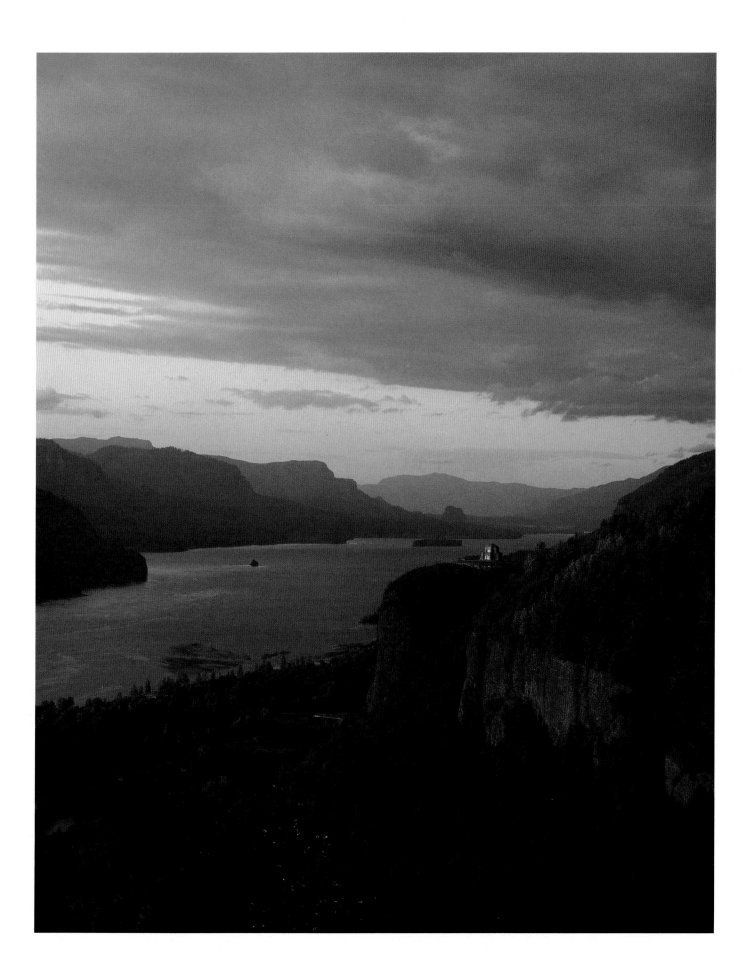

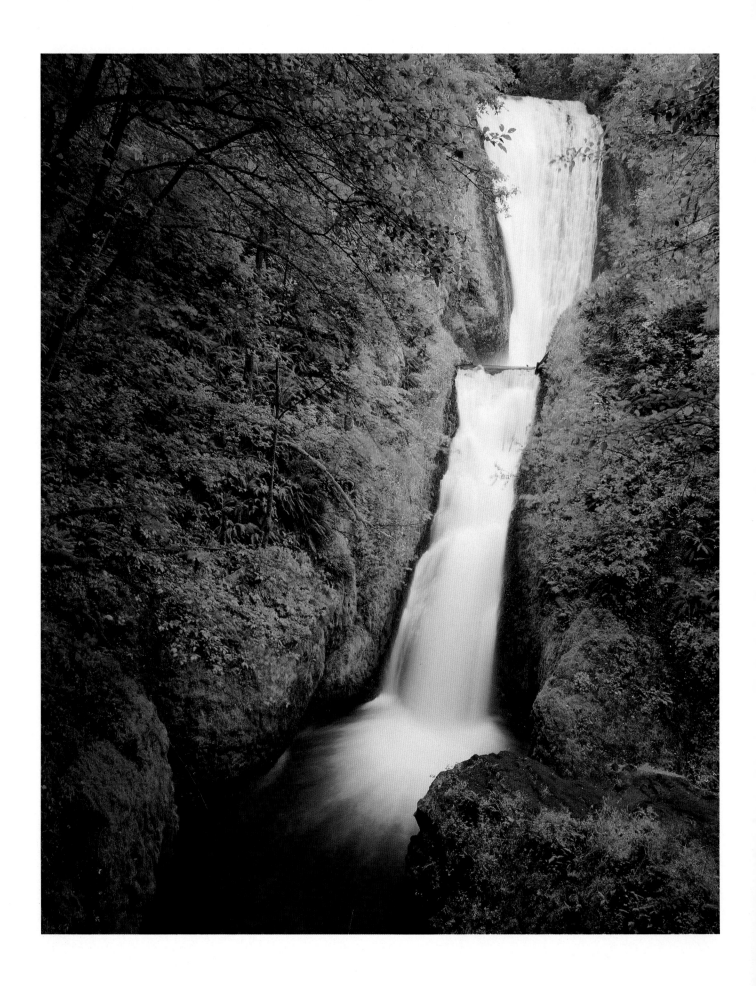

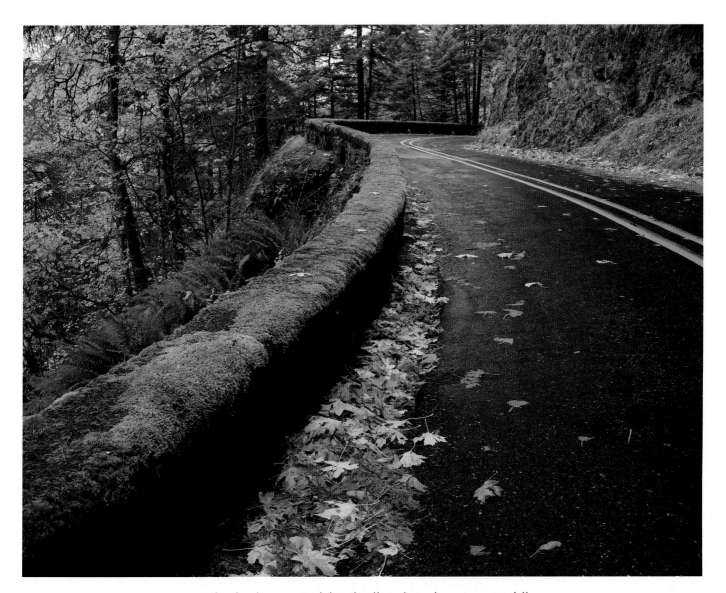

◄ The diaphanous Bridal Veil Falls is the only major waterfall north of the Historic Highway. Seeing it entails a one-mile round-trip hike from the parking area in Bridal Veil State Park.
▲ Before I-84 was finished in the 1950s, the Historic Highway was the only road through the Gorge. The first major highway in the Northwest, it is now a National Historic Landmark.

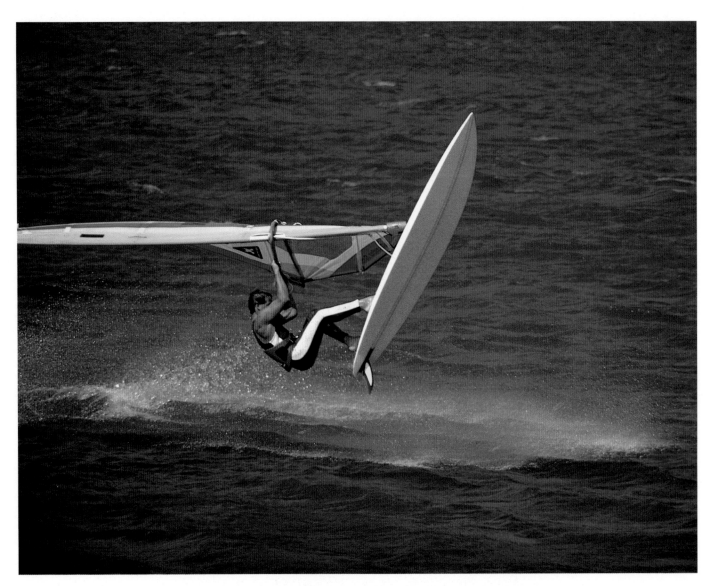

▲ The town of Hood River is called "the windsurfing capital of the world." Annual windsurfing events headquartered at Hood River include the Gorge Cities BlowOut, Killer Loop Classic, High Wind Classic, and Columbia Gorge Pro-Am.
▶ Hood River Valley celebrates spring blooming of apples and pears with a two-day Blossom Festival in late April.

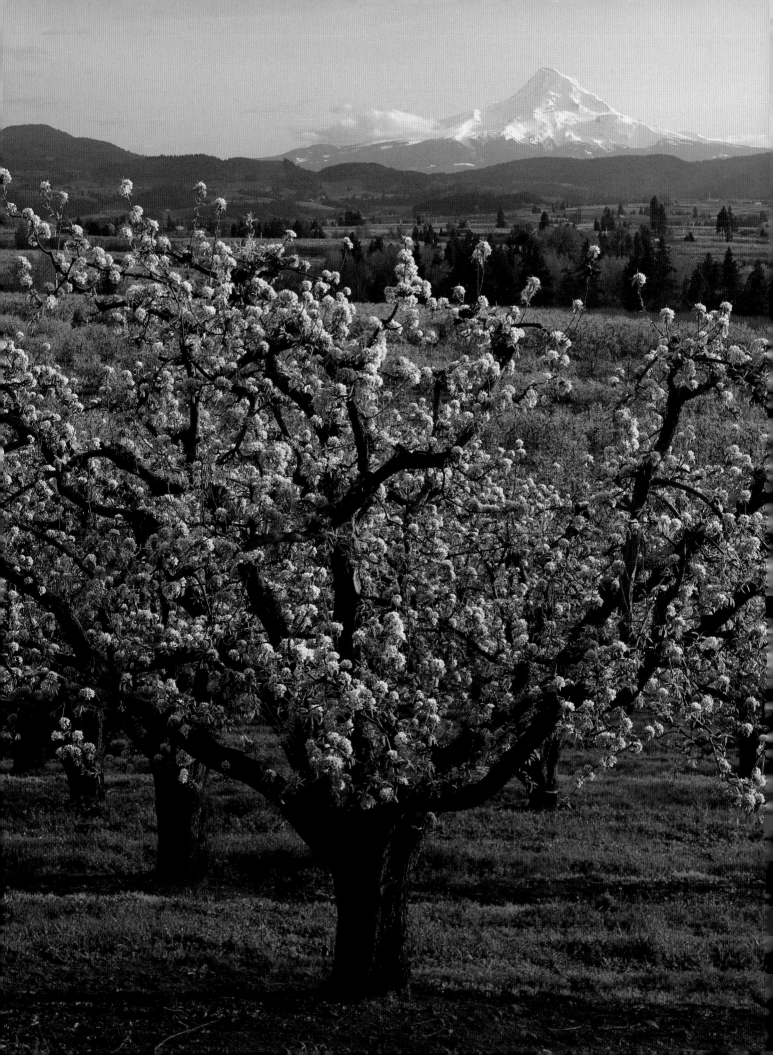

The Cascade Range

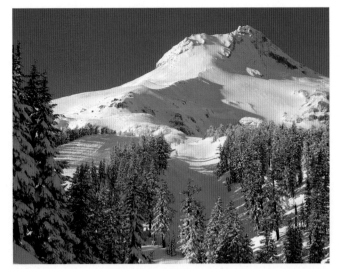

Mount Hood Meadows, Mount Hood's largest ski area

On a clear day you can see it one hundred miles away. Its glacier-mantled summit rises high above a host of whale-back ridges and rocky spires that in any other place would be sovereigns in their own right. But here there is only THE Mountain—a great, free-standing monarch born of volcanic eruptions and furrowed by eons of ice. It is quiet now, a slumbering volcano whose peak rises 11,235 feet above sea level and whose national forest covers more than a million acres. Its heights are so accessible it ranks first as the most-climbed peak in America and second in the world behind Japan's Mount Fuji. It is Mount Hood. And it looms over northwestern Oregon like a white-robed colossus.

It is the highest mountain in the state's foremost range. As part of the Cascades, which stretch from British Columbia to inside California, Mount Hood and its lofty attendants comprise all of Oregon's mountains over 10,000 feet high, with four other peaks exceeding 9,000 feet and at least seven others topping 8,000 feet. Because the range extends the length of the state, it has divided Oregon into two climatic regions. The west side is wet, mild, and heavily forested; the east side is arid, sunny, and open. The Cascade crest, which averages more than 5,000 feet in height, is an almost alpine wilderness set amid black lava rock, cinder cones, and glacier-gouged basins filled with sapphire waters.

Within the Oregon Cascades are seven national forests containing more than seventeen designated wilderness areas. The Three Sisters Wilderness area, on the range's eastern side, is one of the state's largest primitive areas. Not only is it home to Oregon's biggest ice field, the Collier glacier, it is also a World Biosphere Reserve and, as such, is scientifically valuable. So much forested wilderness has made the Oregon Cascades one of the most popular areas in the state. Hiking trails abound, as do campgrounds, lakes, rivers, resorts, and ski areas. It is a recreational mecca, bar none.

For many, skiing is the name of the game. Mount Hood is ever-popular, boasting five ski resorts—all within little more than an hour of Portland. Timberline, with its world-famous lodge, is a year-round resort and claims the nation's only all-summer skiing. Not surprising, then, that the United States Ski Team trains here. The Ski Bowl, with sixty-one runs, is the country's largest night-lit ski area, and Mount Hood Meadows, so popular it draws more than thirty thousand skiers each year, is one of the largest ski areas in the nation. Mount Bachelor, on the range's eastern edge and easily accessed via Bend, is also popular, rated by ski magazines as one of America's top ten winter resorts.

Oregon's Cascades boast many superlatives. Crane Prairie Reservoir claims one of the highest osprey nesting densities in North America; the Metolius River is one of the nation's largest spring-fed rivers; the Three Sisters Mountains are among the most glaciated peaks in the lower forty-eight; and the black lava moonscape along McKenzie Pass reveals the most extensive volcanic legacy on the continent.

Unequaled elsewhere in the Cascade Range is Crater Lake, situated atop a mountain that literally lost its head. Geologists call it Mount Mazama, and until about sixty-eight hundred years ago it stood twelve thousand feet high. Like its Cascade counterparts, Mazama vented its volcanic fury. Unlike the others, Mazama's pyroclastic displays emptied the summit's underlying magma chamber, reducing the peak to a hollow shell that eventually fell inward, creating a pit more than five miles across and four thousand feet deep.

In time, the volcanic chasm cooled and began collecting snowmelt and rainwater. The result is a nearly two-thousand-foot-deep waterway surrounded by cliffs equally high. Today it is the deepest lake in the United States, second deepest in the Western Hemisphere, seventh deepest in the world—and serves as the heart of Oregon's only national park. Perhaps even more astounding is the lake's mesmerizing color. Here is water so pure that light penetrates unheard-of depths, and as it does, the rainbow-colored prisms are absorbed. Except for the blues. Those hues are reflected back to the surface where they create a color so intense it stuns the senses. Not surprising. This is the Oregon Cascades. Here, nothing is impossible.

◄ *The Mount Hood SkiBowl*

▲ The 3,850-acre Crane Prairie Reservoir in the Deschutes National Forest is named for cranes. The man-made lake is also home to one of the largest osprey populations in the world, with over one hundred nesting pairs in residence.
▶ Mount Jefferson, at 10,497 feet, is the second-highest peak in Oregon. The volcanic sentinel sits just outside its namesake one-hundred-thousand-acre pristine wilderness filled with coniferous forests, mountain meadows, and alpine lakes.

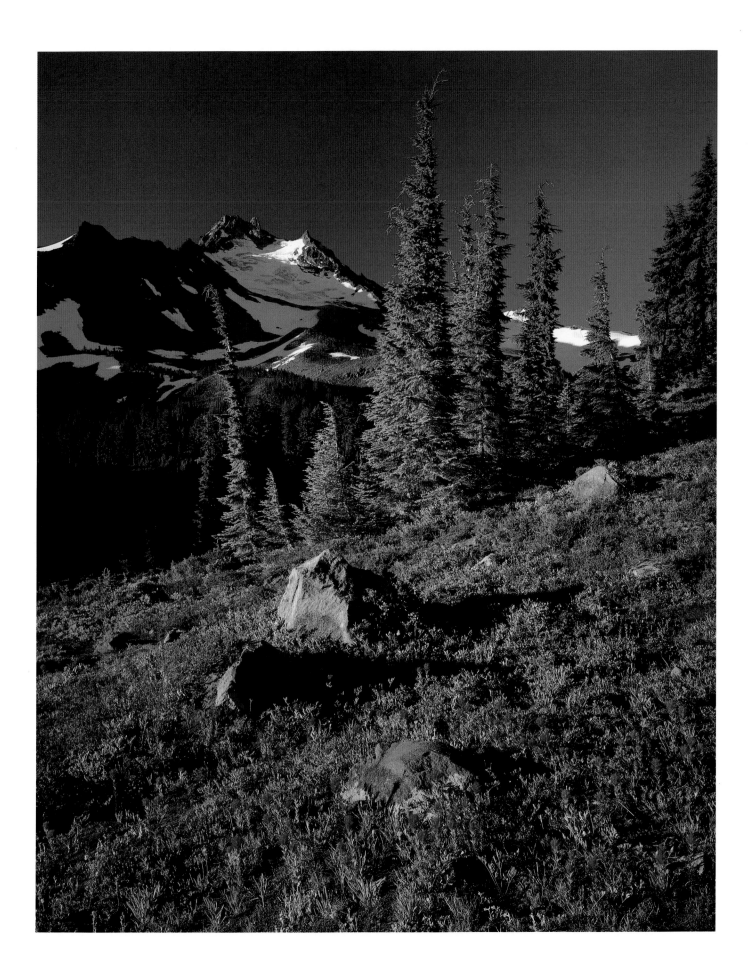

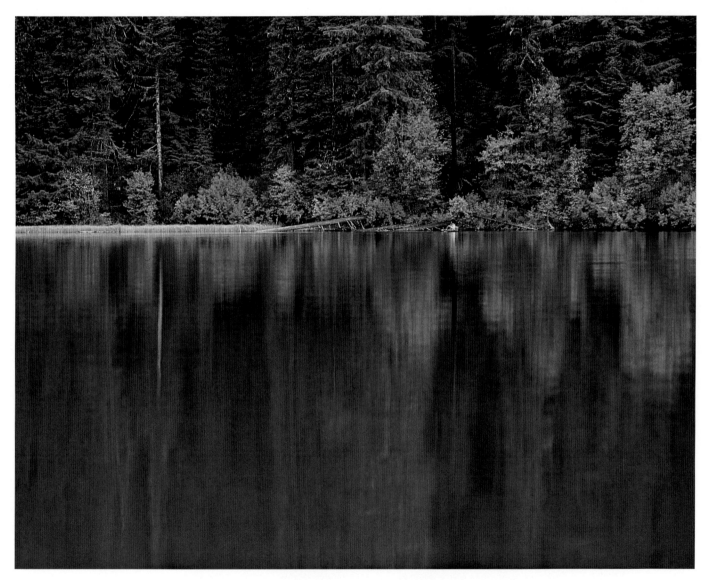

◄ Vine maple's radiance is especially dramatic in the autumn.
▲ At an elevation of 4,130 feet, Marion Lake, in the Mount
Jefferson Wilderness, covers more than 260 acres. It is the
second-largest natural lake in the Willamette National Forest.
►► Sparks Lake, in Deschutes National Forest, covers almost
780 acres. Only seven feet deep, it is a classic example of a
lake evolving into a marsh and meadow. As water evaporates,
the shrubs and trees can colonize ground already laid bare.

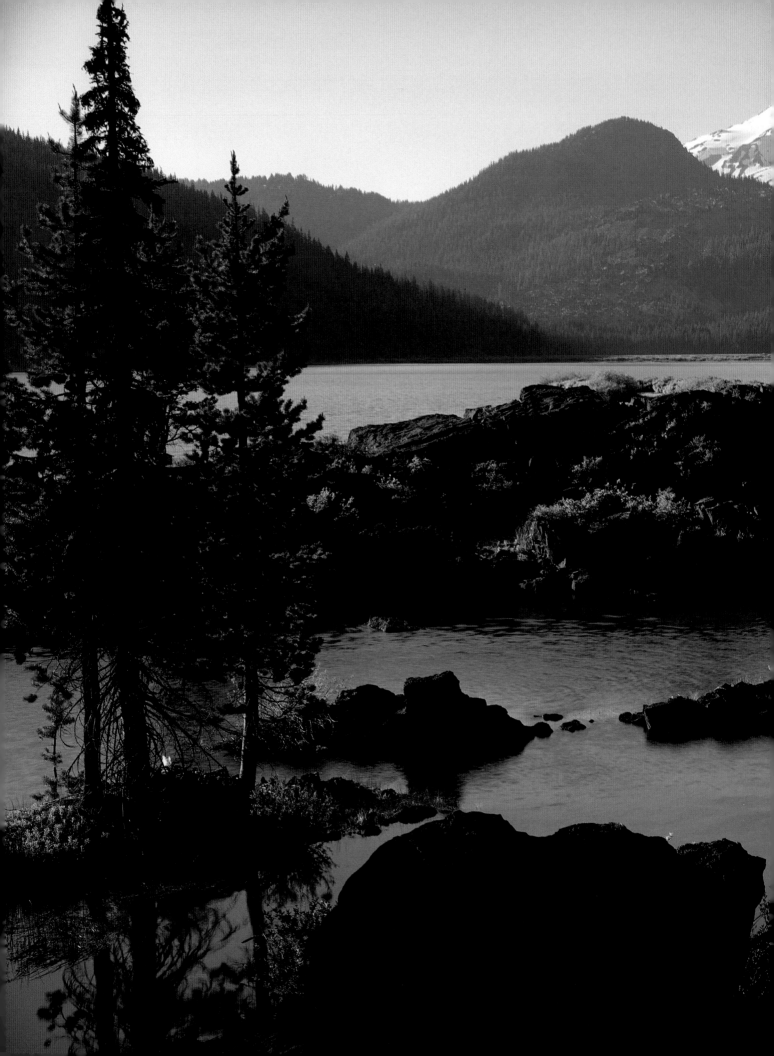

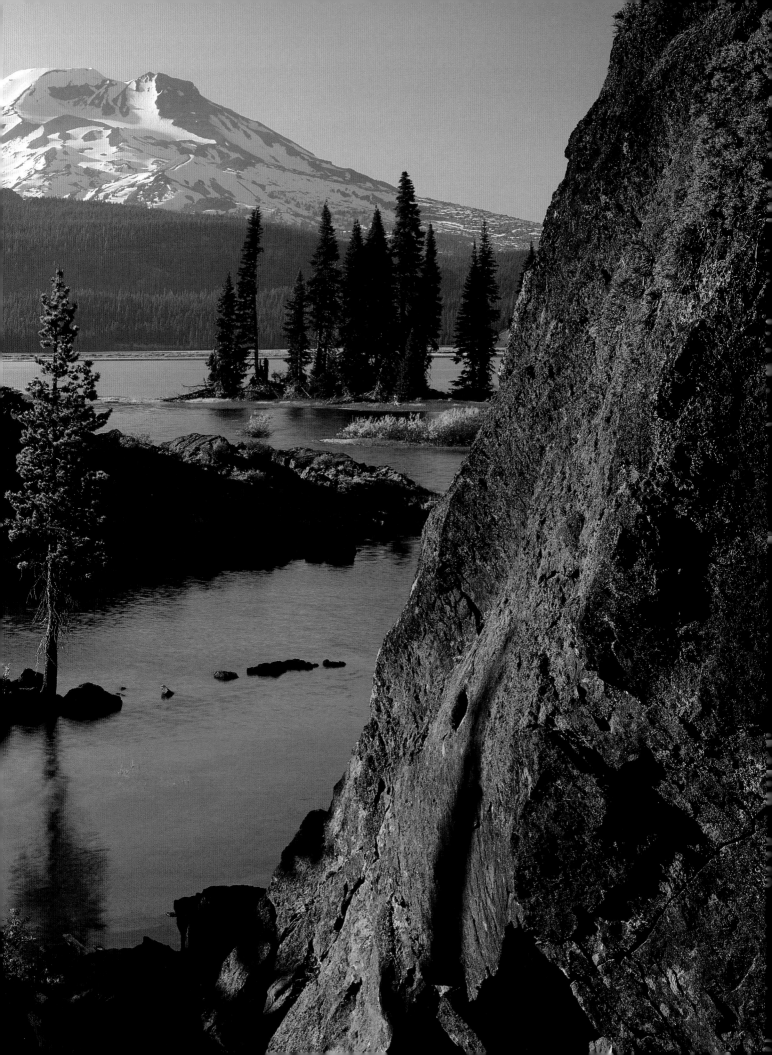

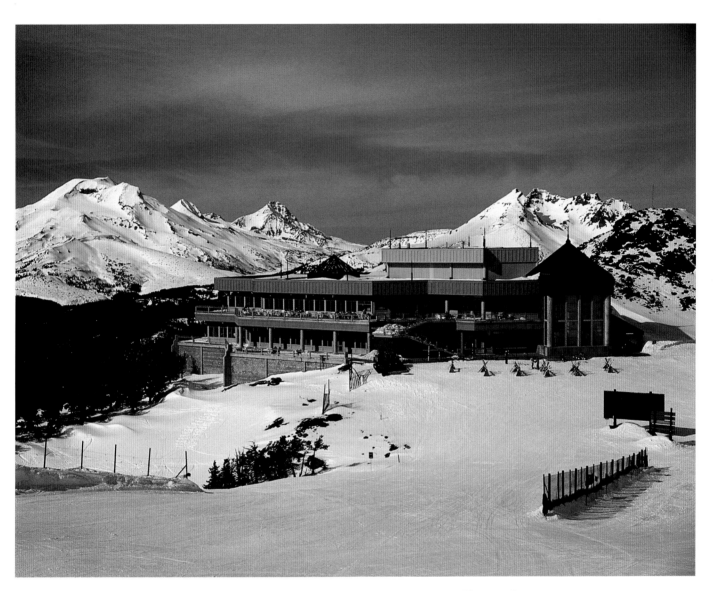

◄ The Dee Wright Memorial Observatory, built of lava rock, sits along McKenzie Pass. The observatory has eleven slotted windows that line up with eleven Cascade promontories, including a 6,415-foot-high cinder cone named Black Butte.
▲ Pine Marten Lodge is one of five day lodges on Mount Bachelor's 9,065-foot summit. In addition to downhill skiing, more than twenty miles of cross-country trails are offered.

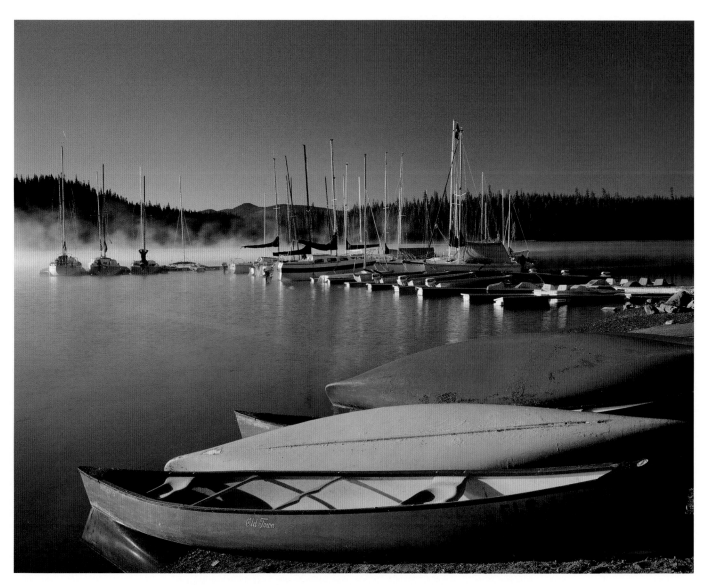

▲ Elk Lake Resort in Deschutes National Forest, is open year-round and includes a marina. In the summer, the breezy lake is popular with sailboarders, boaters, campers, and fishermen. Winter attracts snowmobilers and cross-country skiers.
▶ Three Creek Lake in the Three Sisters Wilderness Area is encircled by the dense forests of the Cascades. Broken Top, Mounts Jefferson and Hood, and Black Butte are visible from the lake, which is a favorite area for fishing and camping.

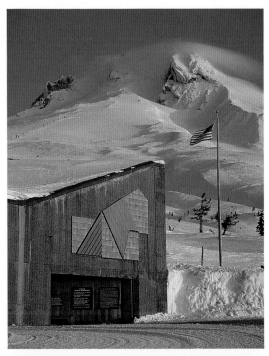
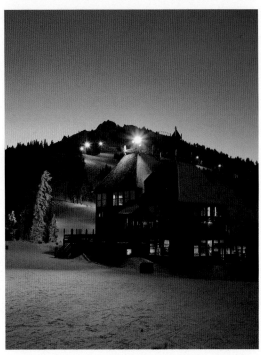

Clockwise above: • Though winter in the Cascade highlands can be harsh, tracks in the snow prove that not all animals spend the snowy months sleeping inside burrows or dens. • The Wy'east Day Lodge at Mount Hood's Timberline ski area was built in 1981 near the historic Timberline Lodge. • Hosmer Lake is famous for its catch-and-release Atlantic salmon population. • Mount Ashland—at the juncture of the Cascade and Siskyou ranges—claims a prestigious ski lodge.

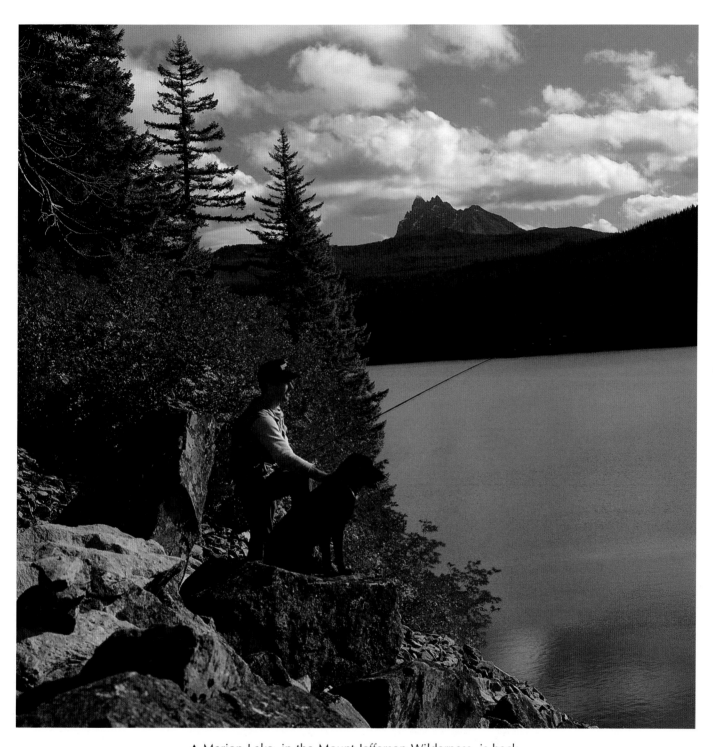

▲ Marion Lake, in the Mount Jefferson Wilderness, is back-dropped by the 7,841-foot-high Three Fingered Jack. The tri-tipped mountain was originally named Mount Marion, but was renamed Three Fingered Jack sometime in the early 1900s. According to legend, the name was changed in honor of a three-fingered outlaw trapper who once lived in the area.

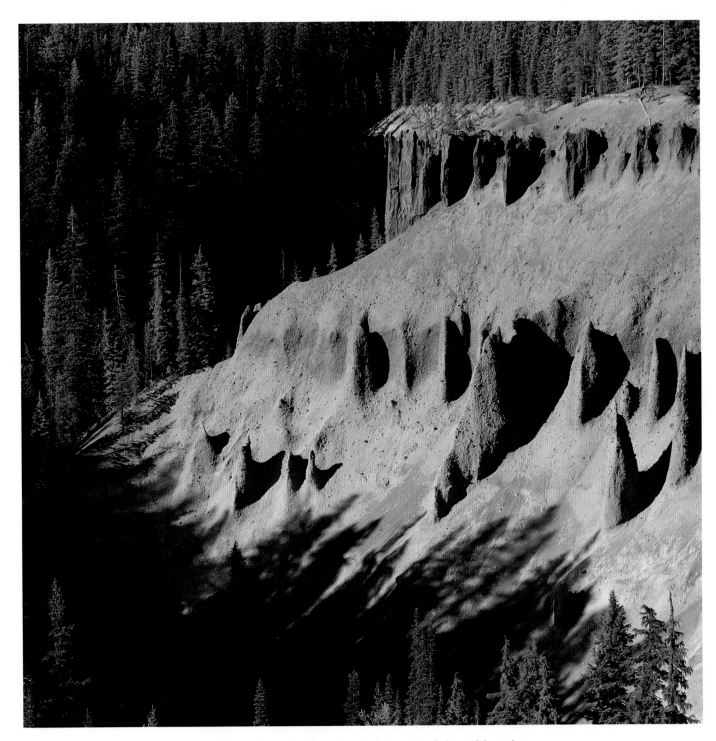

▲ When Mount Mazama erupted, it created the caldera that became Crater Lake and covered Annie Creek Canyon with layers of ash and pumice. Gases bubbling through volcanic vents cemented the layers into rock. Over time, erosion wore away the softer portions, leaving behind volcanic pinnacles.
► Crater Lake covers twenty-one square miles and claims neither inlet nor outlet. Water level remains fairly constant, with snowmelt and rainwater compensating for evaporation.

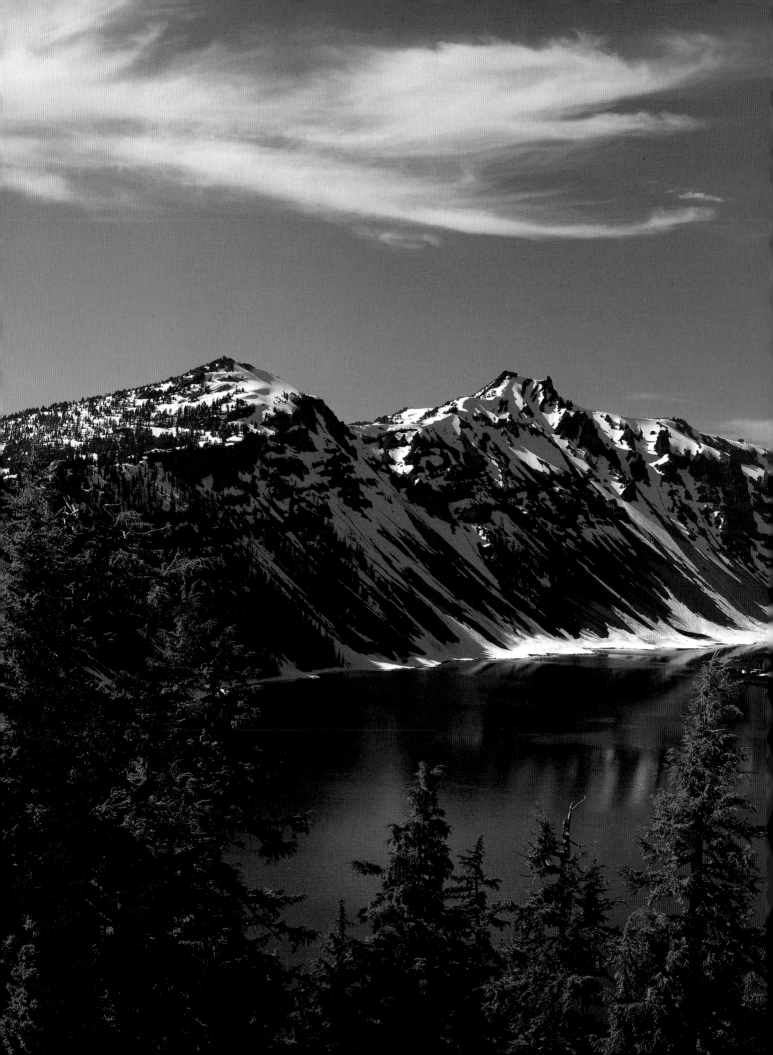

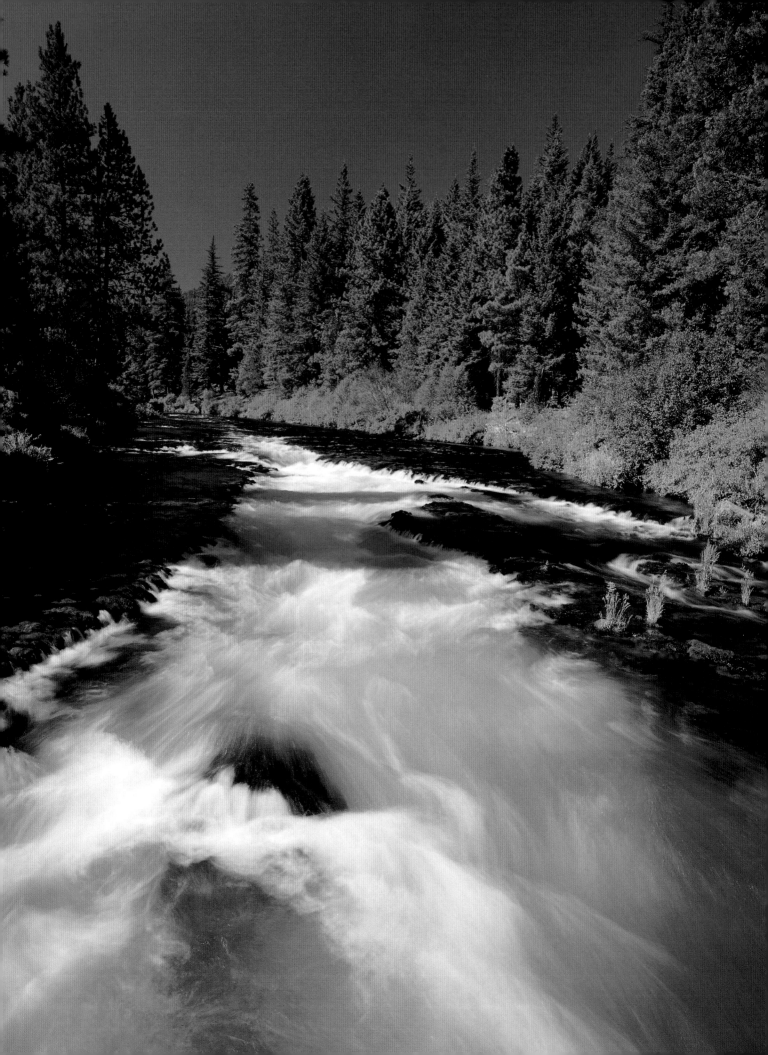

Central Oregon

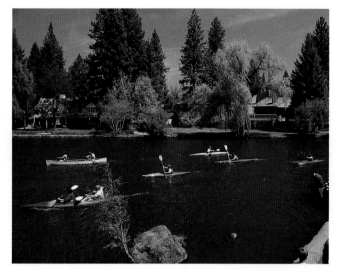

The May Pole Pedal Paddle Race, Drake's Park, Bend

Central Oregon is an intriguing blend of broken volcanic peaks and rushing rivers, black glass buttes and mountain lakes, ancient lava flows and wooded tablelands, lava caves and far-reaching wheatfields, isolated hot springs and high desert rangelands. It is a land whose national forests wear names like Ochoco, Umatilla, and Fremont and whose major rivers are called Deschutes, John Day, Metolius, and Crooked. Its climate is mostly clear and dry; its towns are few and far between; its people have smiling eyes and friendly voices.

The region's focal point is a town situated on the eastern edge of the Cascades on a bend of the Deschutes River. In emigrant days, the spot was such a pleasant stopping place that early travelers were want to bid it goodbye. Thus the spot came to be known as Farewell Bend, and in time it grew into a settlement and then a town. In 1905, when Farewell Bend was incorporated, the ever-succinct post office shortened the name to Bend. No matter. It is still one of the most pleasant stopping places east of the Cascades.

The area claims twenty golf courses, over five hundred miles of bike routes, Oregon's premiere whitewater river, the world's largest commercial reindeer ranch, the nation's largest llama population, a High Desert Museum that reflects the natural and cultural heritage of the inter-mountain west, and the University of Oregon's internationally recognized observatory at Pine Mountain.

The region's many resorts are always popular. The largest is Sunriver, selected by *American Home* as "the healthiest town in America." Close behind is Kah-Nee-Ta, a multi-million-dollar vacation resort owned by the Confederated Indian Tribes of Warm Springs—complete with luxury lodge, tepee encampment, golf course, and seasonal activities like Native American dances, storytelling, salmon barbecues, and the annual Pacific Northwest Championship All-Indian Rodeo held just north of the reservation at Tygh Valley.

About twenty miles south of Bend lies Newberry National Volcanic Monument, established in 1990. Ancient Mount Newberry nearly echoes that of Mount Mazama, for like its Cascade cousin, Mount Newberry was a twelve-thousand-foot-high volcano whose volatile carrying-on resulted in its broad dome caving in on itself. Unlike Mazama, Newberry's five-mile-wide caldera holds two bodies of water: Paulina Lake and East Lake.

Both lakes claim rustic resorts, frequented by anglers in summer and cross-country skiers and snowmobilers in winter. Paulina Peak, at an elevation of nearly eight thousand feet rises fifteen hundred feet above the two lakes, and those who take time to drive to its top can look down into the throat of the old volcano and out across a bevy of cinder cones, rhyolite domes, and the nation's largest obsidian flow.

Across the Central Oregon Plateau, in the Upper John Day River Basin, is one of the most outstanding natural deposits of prehistoric fossils ever discovered in North America. The John Day Fossil Beds National Monument covers fourteen thousand acres divided into three units: Sheep Rock, Painted Hills, and Clarno. The fossil beds preserve approximately thirty to fifty million years of Earth history, giving a sort of Alice-Through-the-Looking-Glass image of the eons between the end of the dinosaurs and the beginning of the Ice Age. The fossil beds have yielded everything from leaves, nuts, seeds, and bits of petrified wood to fragments of sloths, rhinos, and primitive elephants, as well as a three-toed horse the size of a sheep and a four-toed horse no bigger than a fox terrier.

Scattered through Central Oregon are vestiges of the past—Lava Cast Forest, formed when molten rock oozed through a ponderosa pine forest, destroying the trees yet preserving their forms to create the world's largest forest of lava-cast trees; Glass Butte, rising two thousand feet above the desert floor and claiming title as the earth's largest-known outcropping of iridescent obsidian; Perpetual Geyser, sending 200° water skyward every ninety seconds. And all of it set amid a widely skied land that boasts more than 500 miles of rivers and streams, 150 mountain lakes, and millions of acres of pine forests. No wonder Central Oregonians think they have it all.

◄ *The Metolius River*

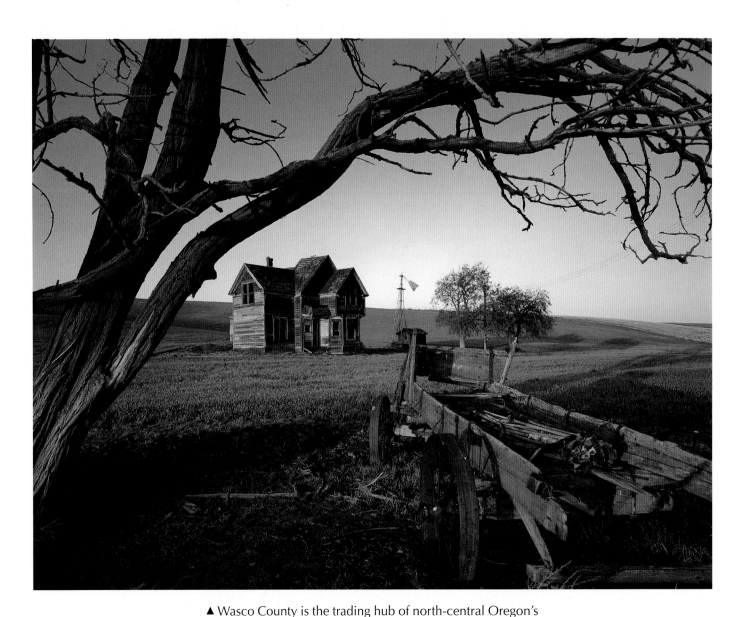

▲ Wasco County is the trading hub of north-central Oregon's agricultural economy. One of its mainstays is winter wheat.
► The Painted Hills unit of John Day Fossil Beds National Monument lies just north of Mitchell off U.S. 26. The eroded, rounded hills are cast of volcanic ash, courtesy of eruptions in the Cascades over long periods of time. The striped and banded multicolored hills are beautiful in any season—but are especially mysterious when blanketed by fresh snowfall.

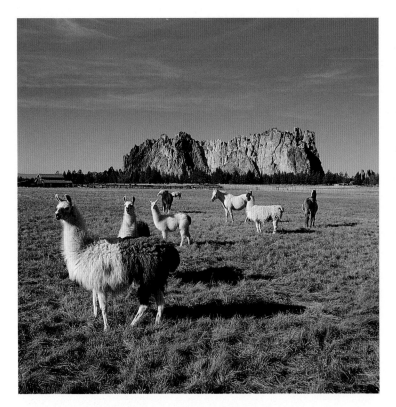

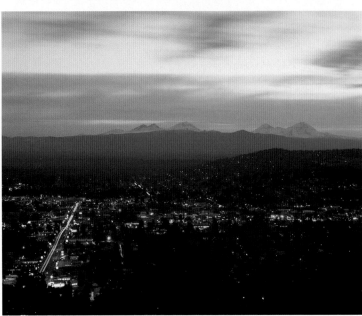

Clockwise above: • Central Oregon claims more than a hundred llama ranches, making it the llama capital of the United States. • The barn owl, efficient at controlling mice and rats, makes its nest in any natural cavity—in cave, barn, or attic. • Smith Rocks State Park, with three-hundred-foot rocks and more than two hundred climbing routes, is known as the best rock-climbing place in the country. • The city of Bend is built on a wooded tableland at the foot of the Cascade Mountains.

▲ The High Desert Museum six miles south of Bend displays walk-through exhibits and interactive displays depicting the natural and cultural heritage of the intermountain west— the land that lies between the Rockies and the Cascades.
▶ ▶ Smith Rocks State Park, established in 1960, covers 623 acres and preserves the prodigious rock spires of an especially scenic section of the Crooked River Canyon. Rock climbers have been ascending these walls since the 1940s.

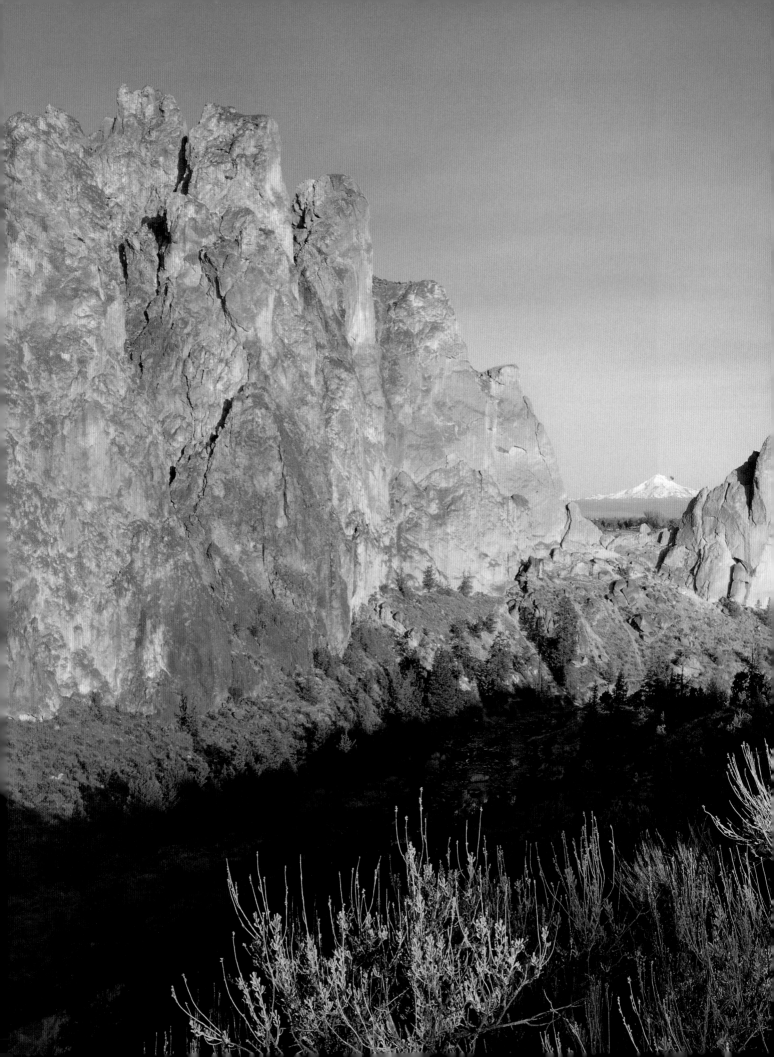

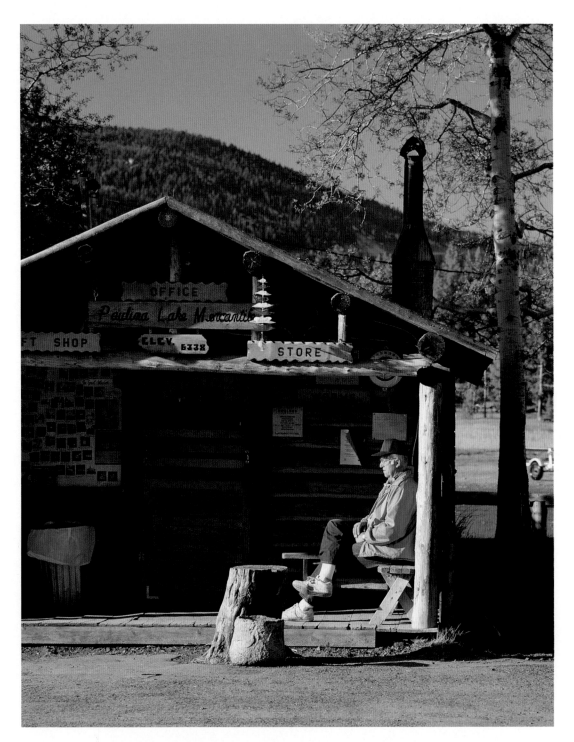

▲ In Newberry National Volcanic Monument, the collapsed throat of ancient Mount Newberry contains cinder cones, pumice, rhyolite flows, forests, and two bodies of water—East Lake and Paulina Lake—both with their respective resorts.
▶ Abert Rim, north of Lakeview, is one of the largest and highest exposed fault scarps in North America. The two-thousand-foot-high, thirty-mile-long rim looms above the saline and odorous Lake Abert in the Crooked Creek Valley.

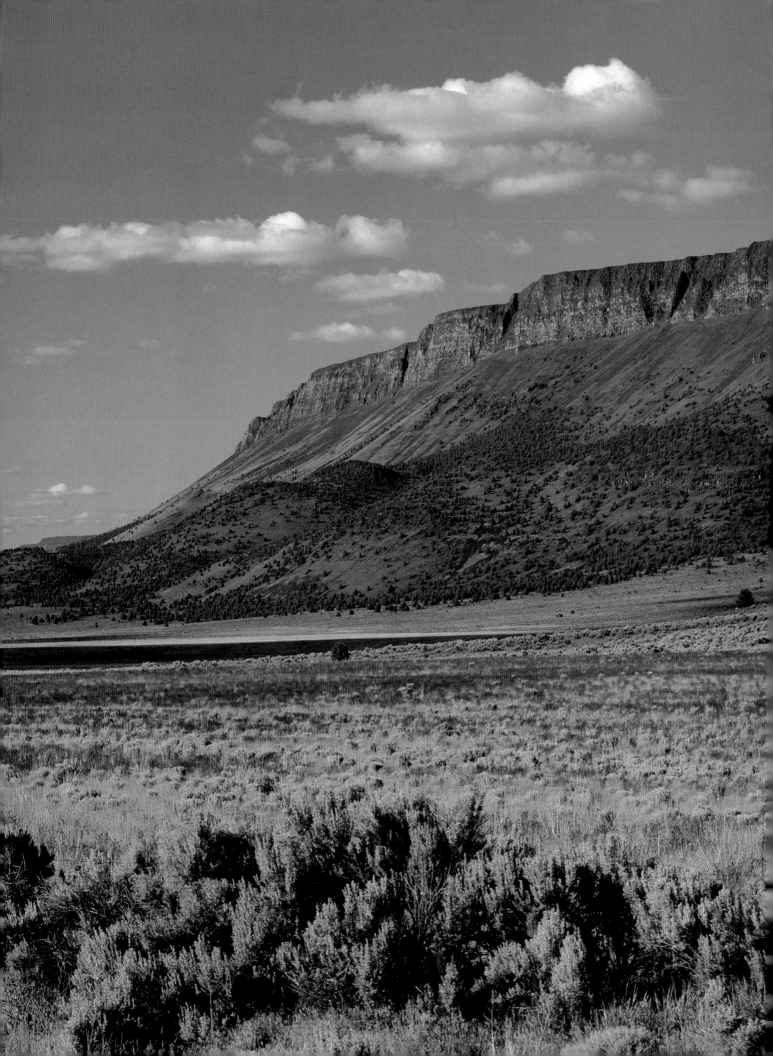

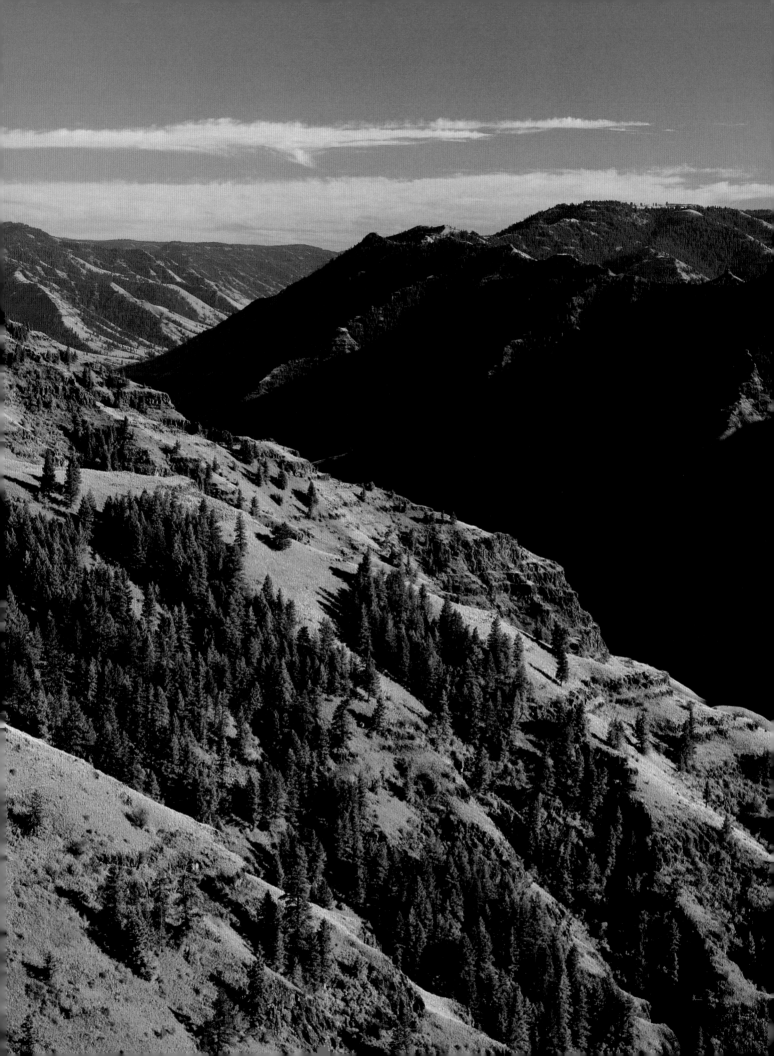

Eastern Oregon

Hart Mountain National Antelope Refuge, 275,000 acres

Eastern Oregon has more than a few nicknames. It calls itself Cowboy Country, Oregon Trail Country, and Big Sky Country. All are apt. This is a land where ten gallon hats and cowboy boots are the standard and white-faced cattle have the right-of-way on public roads; where trail ruts more than 150 years old are still visible, and hundreds of historical markers explain the greatest saga of human endurance ever undertaken on American soil; where rolling wheatlands give way to sagebrush flats studded by caprock buttes and far horizons meld with what seems almost infinite sky.

It is remote, sparsely settled, and almost monotonously sunny. Few would call it Tourist Country. Yet this section of the state boasts some impressive plaudits, for here is one of the largest mountain-rimmed basins in America, the highest and longest aerial tram in the country, one of the biggest elk herds in the nation, one of the prettiest mountain valleys in the American West, and the only national antelope refuge in the entire United States. Add to that the castle-like geology of the Succor Creek State Recreation Area, the Bryce Canyon resemblance of Leslie Gulch, the ruggedly handsome canyon of the Owyhee River, the unspoiled reaches of the Eagle Cap Wilderness, and the diversity of wildlife roaming the 2.4 million acres of the Wallowa-Whitman National Forest.

Crown jewel of the area is Hells Canyon. Here, where the Snake River has carved a natural boundary between Oregon's Wallowa Mountains and Idaho's Seven Devils Range, is a nearly perpendicular chasm whose average depth is sixty-six hundred feet—making it North America's deepest gorge. The river canyon is the centerpiece of Oregon's Hells Canyon National Recreation Area, a remote wonderland that sprawls across 662 thousand acres of alpine peaks, high desert, and secondary gorges.

East of Hells Canyon, in the Wallowa-Whitman National Forest, is an out-of-the-way mountain valley so spectacular it is called "the Switzerland of America." The name fits. The nearly ten-thousand-foot-high Wallowa Mountains tower over the lakes and grasses of Wallowa Valley, creating a place

set apart—a land of cottonwoods and poplars, red barns and white ranch houses, frolicking sheep and stodgy cattle, whispering streams and placid lakes. Lake Wallowa, the largest body of water in all northeastern Oregon, fills a six-mile-long glacier-carved basin at the foot of Mount Howard. Here, too, is the Wallowa Lake State Park, one of the largest in the state, and the Wallowa Tram, the steepest and longest aerial tram in the nation.

Less than two hours east of the valley is I-84, which mainly parallels the route of the Oregon Trail from the Snake to the Columbia River. Flagstaff Hill, just outside of Baker City, was a well-known stopover along the trail, and the prairie here still bears the scars of the thousands of covered wagons that passed this way. Today, a single barnlike structure sits atop Flagstaff Hill, and though its exterior seems commonplace, there is nothing common about the museum within.

It is the finest exhibit center in the West—a ten-million-dollar complex built as an Oregon Trail Interpretive Center. The building houses a mock wagon train complete with full-size people, animals, and wagons, and a sound-track second-to-none. Other displays include artifacts, audio-visual programs, living history productions, diary and letter excerpts, wall-size maps, and a full-grown buffalo—stuffed and tucked into a corner nitch where it surprises more than a few who had no idea they were about to meet it eye-to-eye.

North of Baker City is La Grande and the Grande Ronde Valley, one of the nation's largest mountain-rimmed basins. To the north and west are the Blue Mountains; to the east, the Wallowas. To the Nez Perce, it was the Valley of Peace. To the French-Canadian trappers, it was La Grande Ronde, the great circle. North of the valley lies northeastern Oregon's largest city, Pendleton. Wheat, farming, and cattle keep Pendleton's economy moving, augmented by a world-famous woolen mill and by an equally famous rodeo. The town bills itself as "Not the new west, not the old west, but the REAL west." The slogan befits all of Eastern Oregon. For here, more than any other region in the state, the romance of the West prevails.

◄ *Hells Canyon National Recreation Area*

▲ The snow-streaked ramparts of the nearly ten-thousand-foot-high Wallowa Mountains rise straight up out of the Wallowa Valley and are unique in Oregon because they are granitic, rather than volcanic, in origin. The Wallowa Mountains are home to the Eagle Cap Wilderness, one of the most rugged and unspoiled primitive areas in the nation.

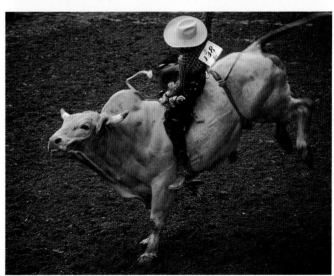

Clockwise above: • About seventy miles of the Snake River's thousand-mile length flows through Hells Canyon National Recreation Area. • The Oregon Trail Interpretive Center near Baker City is one of several new facilities finished or planned along the trail from Missouri to Oregon City. • The Pendleton Round-up began in 1910 and today attracts the country's top rodeo performers. • Eastern Oregon State College is the only four-year liberal arts college in all of Eastern Oregon.

▲ The highway between Burns and Frenchglen crosses the Malheur National Wildlife Refuge in the Blitzen River Valley. The 183-thousand-acre preserve was set aside in 1908 as a shelter for egrets, cormorants, and ibis. Today, some 280 bird species use the refuge as a stopover along the Pacific Flyway.